IMAGES
of England

FILTON
AND THE
FLYING MACHINE

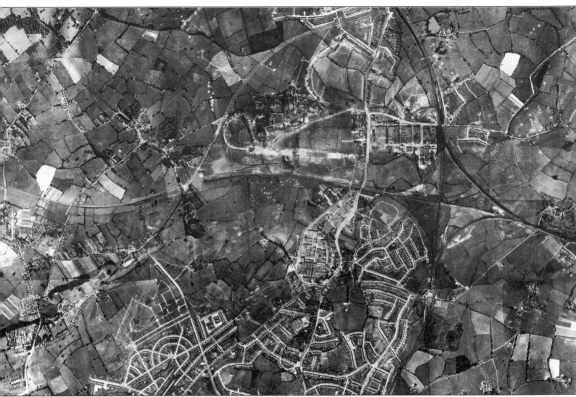

This extensive aerial photograph was taken early in the Second World War and provides a useful bird's eye view of the whole area. The main railway line to Wales runs across the middle of the photograph, with Filton village and an incomplete Southmead on the southern side. The Patchway works are immediately to the north of the line. The original runway can also be seen to the north, lying parallel to the railway, with Charlton village further west, awaiting its fate.

IMAGES
of England

FILTON
AND THE
FLYING MACHINE

Compiled by
Malcolm Hall

TEMPUS

First published 1995
Reprinted 1997, 2000
Copyright © Malcolm Hall, 1995

Tempus Publishing Limited
The Mill, Brimscombe Port,
Stroud, Gloucestershire, GL5 2QG

ISBN 0 7524 0171 8

Typesetting and origination by
Tempus Publishing Limited
Printed in Great Britain by
Midway Clark Printing, Wiltshire

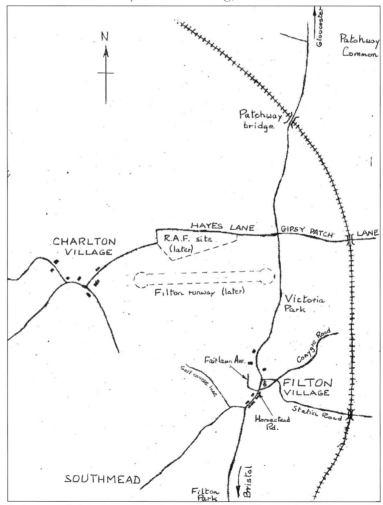

This simplified map of the area as it was around 1910 shows the principal roads and the whereabouts of some of the different localities referred to in this book.

Contents

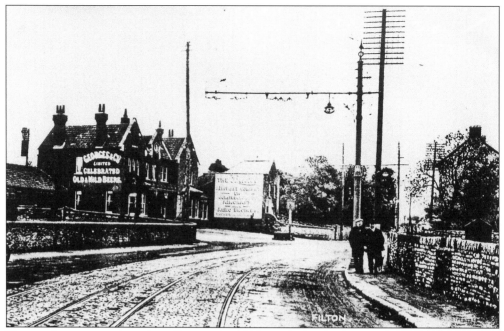

The southern approach to the village in the 1920s, with the Anchor on the left and the Bristol Aeroplane Company's advertisement hoarding on the side wall of Anchor Cottage (no longer standing).

Introduction

Although this book is not principally concerned with the Bristol Aeroplane Company, it was inevitable that that organisation, together with its forerunners and descendants, should have been a major actor in the events of the last eighty-odd years. More precisely, it is about the people of Filton and Patchway and the area in which they lived in the past and live now, at the same time illustrating how the area has gradually altered with the passage of years and how aviation has played a decisive part in that evolution.

Today's visitor to suburban Filton, with its industry, its wide-spread housing estates and its jet-age airfield, might be forgiven if he found it difficult to imagine a very different place – a country parish containing several farms within its boundaries, where horses were more numerous than motor cars, where the engineering activities were represented by a smithy and a carriage works, and whose inhabitants numbered barely 500. Yet, this was the Filton of Edwardian days.

Down the hill, on the road to Gloucester, lay Patchway – scarcely a village at all then – and just across the fields to the west, the small hamlet of Charlton. To the south, but quite separate, was the city of Bristol.

The community was perhaps more self-sufficient, more close-knit than it is

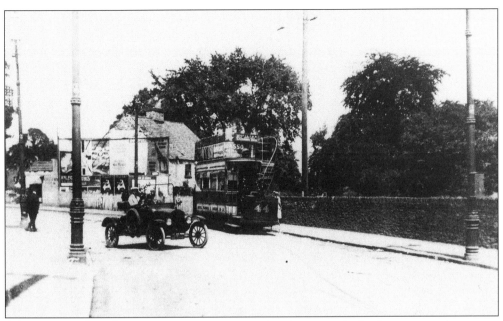

Advertisement hoardings, trams, motor cars, cast-iron lamp standards: the century advances.

now (no telly then!). Filton Brass Band flourished in those days and the Rectory and the School formed the twin centres of community social life. After the First World War, the Filton Memorial Hall was built, while Patchway also had a Hall – "The Hut". (There was a "Hut" in Filton too – alongside the parish church.)

Change is, of course, always with us and there is never one point in history where a particular evolution can be said to have begun. The year 1910 and the arrival of aviation were certainly seminal for Filton, yet, before that, there was the coming of steam, while, in the village itself, the rural atmosphere surely changed perceptibly when the first tram clanked in from Horfield, loudly announcing its twentieth-century electro-mechanical heritage.

Such changes came slowly at first, but change has quickened in more recent years. In the twenties and thirties, several farmers were still working the land around the village. Filton Hill Farm, at the end of Filton Avenue, where the Rolls-Royce Technical College now stands, did not disappear until 1953.

Between the wars, typical unpopular phenomena of today such as traffic density and noise had not attained anything like current levels – although they were beginning to cast their shadows before them. Even the airfield still owed more to the countryside than the town. The aeroplanes which took off from its all-grass surface were, compared to today's powerful jets, relatively gentle, relatively quiet (although there were complaints about noise – even then!).

After the Second World War, the pace quickened again; the Brabazon cast its giant shadow for a while, 501 Squadron's Vampire jets whistled around the airfield, and then, in the fullness of time, came Concorde.

Now, in the last decade of the twentieth century, change is all-pervasive. Patchway has, like Filton, become a densely populated dormitory suburb. Just beyond its boundaries, the building work creeps onward and outward, with the arrival, first of Aztec West, and now Bradley Stoke and the industrial and commercial estates filling the space between the airfield and Cribbs Causeway. Even where concrete has not oozed over the earth, the grassland which remains, such as that trapped between the airfield's boundary fence and the garish pavilions of the hypermarket village, can only be described as abandoned wasteland.

Yet, away from such man-made deserts, much still remains to please the eye, as the imaginative authors of the signposted walk called the Patchway Greenway have shown. And although old Filton and Patchway have all but disappeared – Charlton, indeed, has gone totally – yet they remain with us, thanks to the medium of film and to the photographers who, down the years, captured past scenes and events while they were still a part of their present.

This verdant lane is not in the depths of the countryside, far from the madding crowd, but is a short stretch of the circuit signposted as the Patchway Greenway.

One
A Rural Village

As the twentieth century dawned, Filton was a small country village, as yet still detached from the city. The community was basically agricultural; farmland surrounded it on all sides and modern bustling Filton, today seamlessly welded to Bristol, lay far in the future. A man, turning his gaze southwards from the top of St. Peter's squat church tower, would have seen acres of green fields before his eye discerned the roofs and smoke of the port of Bristol. In place of today's clamorous, dual-carriageway A38 was a quiet, tree-lined country road, winding its leisurely way up Filton Hill, near the end of its journey southwards from Gloucester to Bristol.

Much – too much – from those days has now gone, but the informed eye will still find, here and there, mingling with the undistinguished building of the late-twentieth century, vestiges of old Filton and Patchway which survive. There is Filton House itself, as well as Fairlawn House and Rodney Hall, all within B.Ae.'s premises; Filton Church, naturally; Samuel Shield's old house, now Lloyds Bank; the Anchor, abandoned and forlorn; and Pond Farm, once on Patchway Common, now a private house in the midst of a residential area.

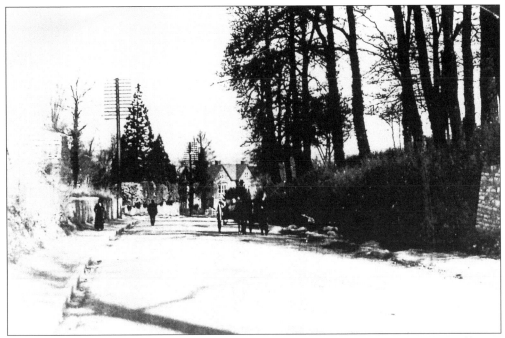

Filton Hill (Gloucester Road) in the early 1900s. Looking downhill towards Rodney Hall.

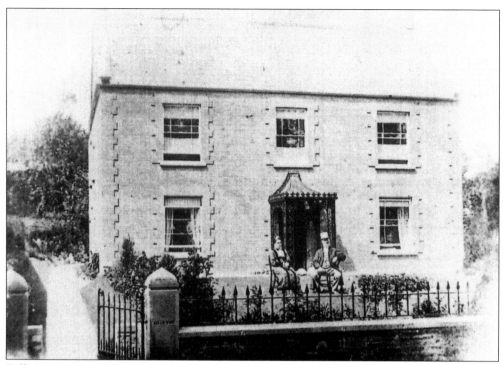

Belle Vue House, Conygre Road, in 1880. (The Red House)

Pound Corner in the 1880s, on the corner of Church Street and the Gloucester Road. The Pound is the small building to the right of centre.

The Horseshoe Inn in 1881, since rebuilt. Richard Attwell's forge lies to the right.

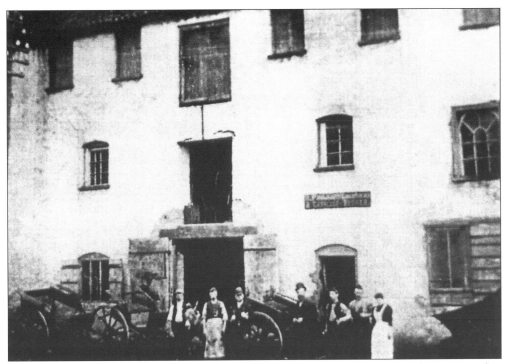

On the other side of the road, opposite the Anchor Inn, were the workshops of carriage-maker Robert Phillips.

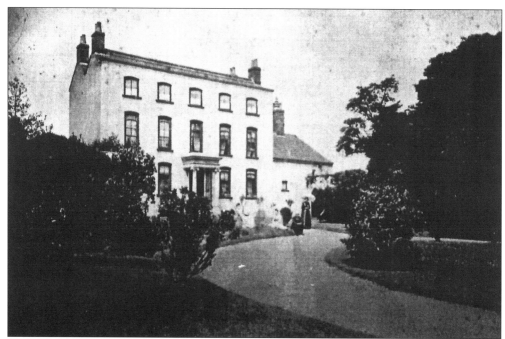

Filton House in the 1880s, when it was still a private residence. It was purchased by the British and Colonial Aeroplane Company in 1912 and is still owned by British Aerospace today.

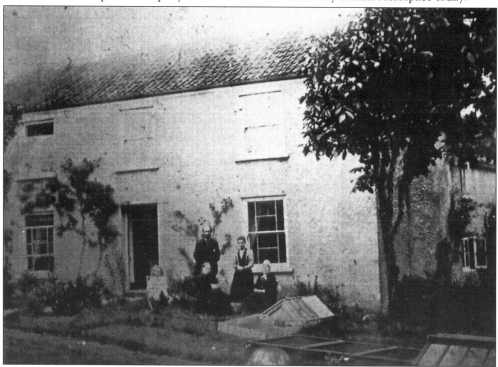

Meadowsweet, Conygre Road, in 1890, now demolished. The group – a well-known Filton family – consists of John and Charlotte Gayner, their daughters Elsie and Lucy, and Martha Sturge. Both the house and the family are remembered in local road names.

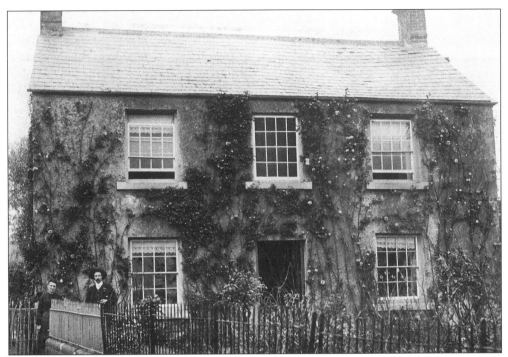

The Roses, in Hempton Lane, Patchway, c.1896.

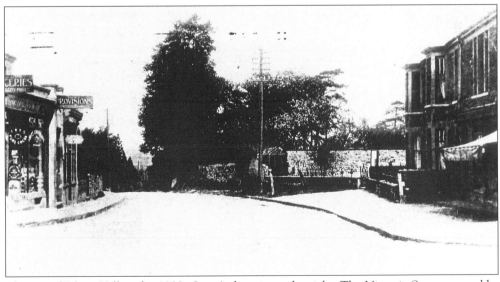

The top of Filton Hill in the 1900s. Lane's dairy is on the right. The Victoria Stores, owned by Edward Gough and Henry Attwell, is on the left.

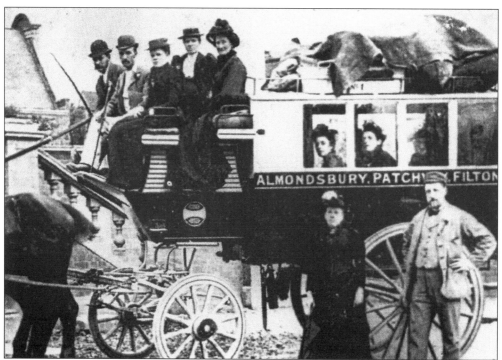

The Almondsbury to Filton omnibus in 1893.

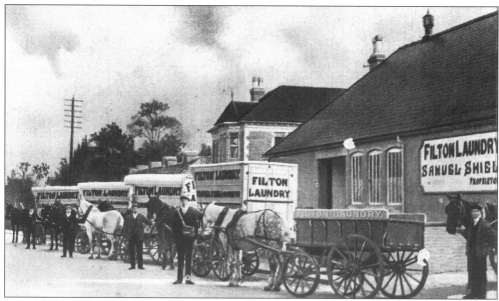

The village was not without the suggestion of modern industry. By 1900, Samuel Shield's laundry, with its tall, factory-like chimney, had already been in operation for some thirty years. Horse-drawn delivery vans are shown here drawn up outside Filton Laundry, opposite the Anchor, in 1906. The laundry building on the right was knocked down and replaced by the Technical College. The building next to it – Samuel Shield's residence – still stands, occupied today by Lloyd's Bank. Beyond that can be seen the chimney pots of the row of terraced cottages known as The Rank.

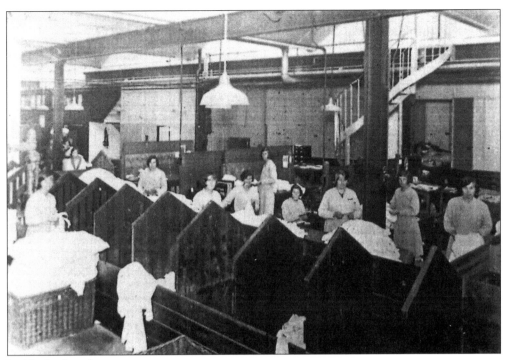

Inside the laundry.

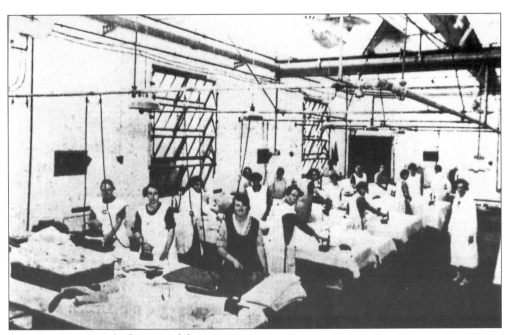

Laundering was no doubt a very labour-intensive activity.

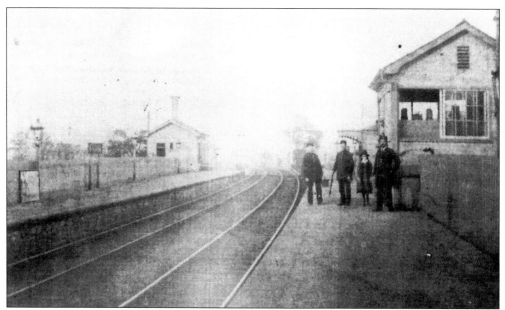

As with most places, the modern age came to Filton by stages. First to arrive was the railway, driven through in the 1860s. Steam trains drew up at Filton Station, on their way to and from Bristol and South Wales, via the Severn Tunnel. The photograph shows Filton Station in 1900. It then lay on the southern side of the bridge over Station Road. In 1910 it was replaced by Filton Junction, to the north of the bridge.

Railway staff gathered outside Patchway signal box.

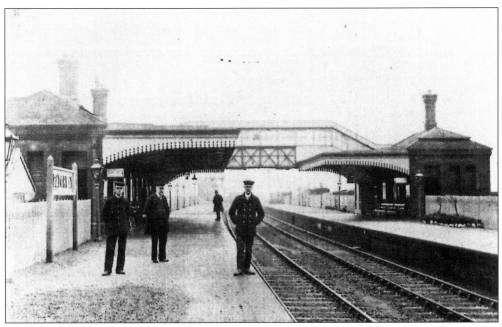

Two views of Patchway Station, emphasising the generous railway architecture of those days. In 1911 the stationmaster was Mr Moore.

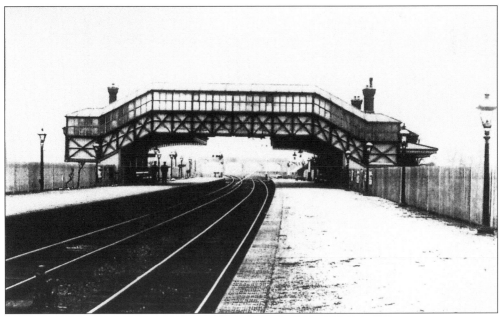

A view from the opposite direction.

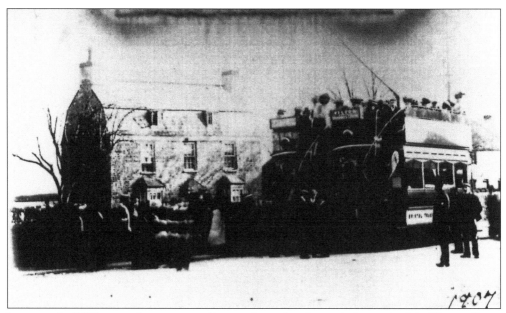

Later on, in 1907, came the trams, rattling out from the city to their terminal in Filton village. Here, two trams are pictured outside the Chestnuts in 1907, the year in which the line was first extended out from Horfield to Filton.

A group in Filton's original Wesleyan Chapel, in Church Road.

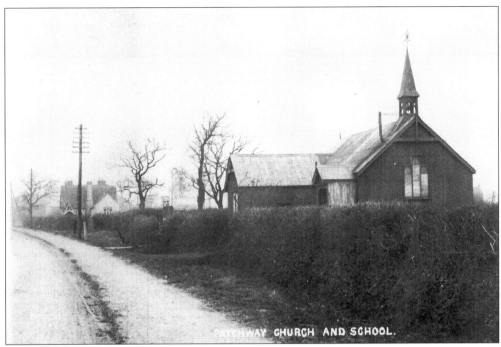

St. Chad's Church, Patchway ("The Tin Church"), with Patchway school beyond, in 1912.

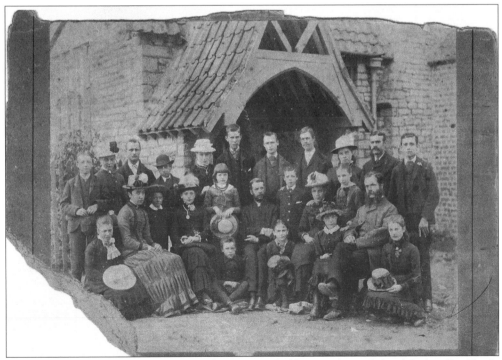

This group was photographed after Sunday Service, held in Patchway School, before St. Chad's Church was built.

Filton Hill in 1910. Looking uphill towards Fairlawn House. The Rectory lies on the far left. No great changes as yet in the country village.

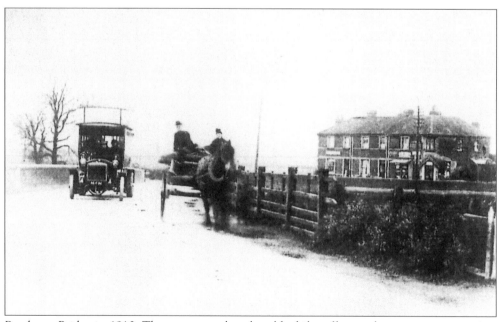

Patchway Bridge in 1910. The new overtakes the old while, offstage, the even-newer was just starting to make its presence felt.

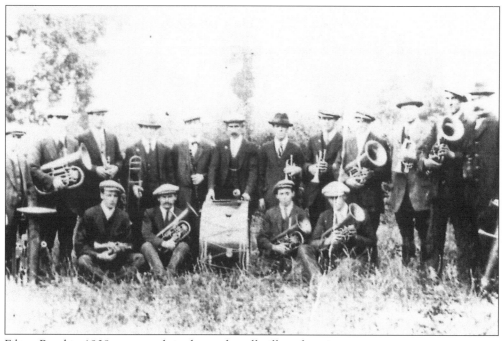

Filton Band in 1908 were much in demand at all village functions.

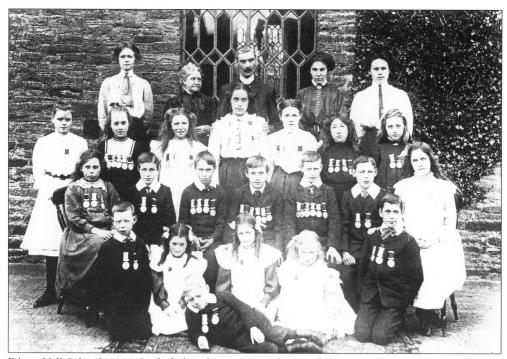

Filton Hill School, 1911. Included in the group are the Headmaster William Baker and teachers Miss Mary Morgan and Mrs Mary Lewis. Medals much in evidence!

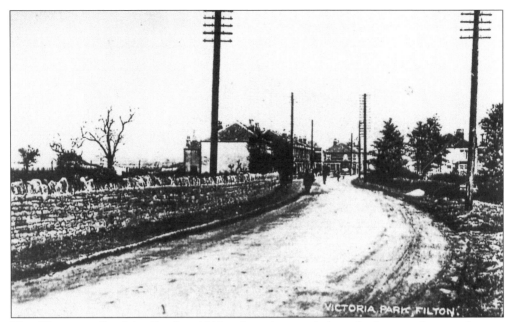

The Gloucester Road in October 1912, where it passed through the area known then as Victoria Park. Some of the houses in the picture were severely damaged in the air raid of 25th September 1940. The land on the left is now occupied by Rolls-Royce's Rodney Works.

A little further north, the tree-lined Gloucester Road in Patchway, pictured in 1910. The Gospel Hall is on the extreme right, with the Railway Hotel in the distance.

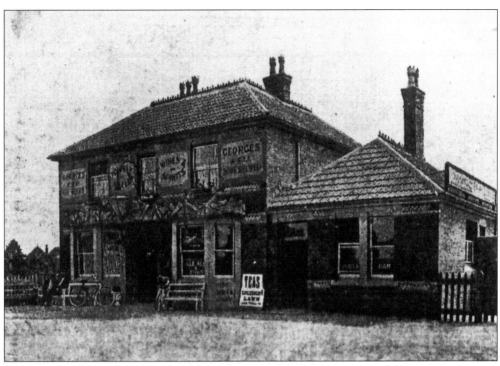

Two views of the Railway Hotel, in the early years of the century.

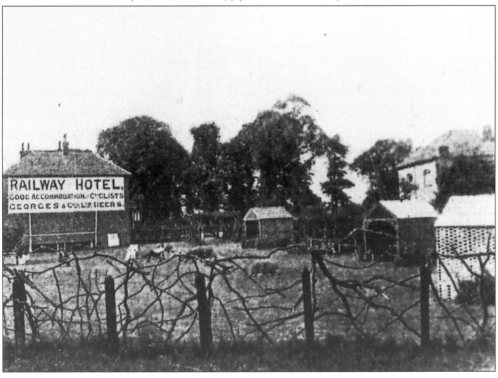

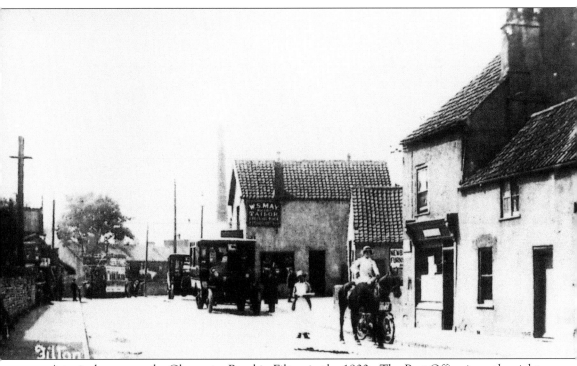

A typical scene on the Gloucester Road in Filton in the 1900s. The Post Office is on the right, The Rank is in the distance behind the tram, and Samuel Shield's laundry chimney can also be discerned.

Another view in the centre of the village, similar to that on page 13.

Two
The Beating of Wings

When aviation first came to Filton in 1910, successful aeroplane manufacture in Britain had not really begun. When, two years after the Wrights' first, relatively unpublicised but successful flights at Kitty Hawk in 1903, Wilbur Wright crossed the Atlantic to demonstrate his new art for the first time in Europe, his choice fell on the then more air-minded nation of France, rather than this country.

However, Louis Blériot's successful conquest of the English Channel in 1909 fired the imagination in this country, while great efforts were being made by a number of dedicated pioneers such as Claude Grahame-White, A.V. Roe and T.O.M. Sopwith. In the next four years up to the outbreak of war, the aviation scene was to be transformed.

Caught up in this transformation was the village of Filton. Nearly sixty years before Concorde, Filton's future destiny was deflected inexorably to aerospace – a word still uncoined – when Sir George White turned from the manufacture of trams to the vastly more exciting prospects offered by the infant aviation industry. Sir George, who had at one time resided in the village at Fairlawn House, picked on this location to be the base for his new enterprise, which he had named the British and Colonial Aeroplane Company.

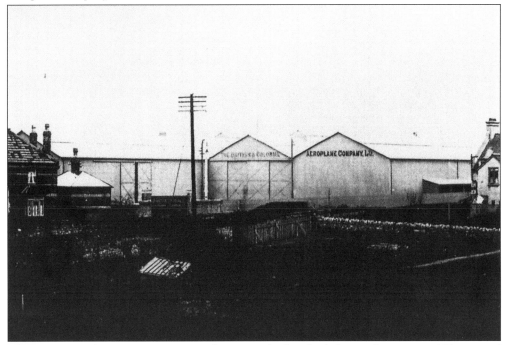

The company's first premises were in these two sheds, which lay at the corner of Homestead Road and Fairlawn Avenue, and had previously been occupied by Sir George's trams.

"ZODIAC" BIPLANE.

TYPE 52 B.

DIMENSIONS.	Width of Span 	33-ft. 3-in.
	Length 	39-ft. 3-in.
	Height 	10-ft. 2-in.

SUPPORTING AREA. 525 square ft.

WEIGHT. Approximately 1,000-lbs.

FRAME. Best Selected Ash and Silver Spruce.

CHASSIS. Tubular Welded Steel.

ENGINE. 50/60 H.P., Watercooled.

PROPELLER. Wooden, directly mounted on engine crankshaft. Diameter : 8-ft. 3-in.

CONTROL. By hand wheel on horizontal shaft operating "fore and aft" for elevation and by turning wheel for operating stabilisers. Steering controlled by foot lever.

PRICE :

Complete with 50/60 H.P. 4 Cylinder Engine .. **£1000**

FLIGHT OF ALL OUR AEROPLANES IS GUARANTEED.

In order to establish itself, the young company had decided to begin by building under licence a machine called the Zodiac, designed by the French brothers Voisin. The first machine was delivered from France and exhibited at the Olympia Aero Show, in London, in March 1910. Brochures were produced, not only detailing the machine's characteristics in precise terms, but also giving categoric and confident assurances concerning its capabilities...

THE BRITISH & COLONIAL AEROPLANES are built at the Company's extensive works at Filton, near Bristol, England.

They are therefore English built, but are based on the designs of the most successful French aeroplanes.

The Company have in association with them the SOCIETE FRANCAISE ZODIAC, of Paris, the designers and makers of the well-known ZODIAC AEROPLANES and DIRIGIBLE BALLOONS, whose Directors are recognised in the flying world as leaders in the subject of aeronautics, and who have devoted the past 25 years to the study and development of aviation in all its branches.

THE BRITISH COMPANY having acquired the sole right to construct and sell the "Zodiac" aeroplanes throughout the British Empire, they are thus enabled to produce aeroplanes, the design and construction of which are the result of years of experience, combining the practical and meritorious features of the most successful types. They are built of the very best material, and every part is constructed with the minutest care.

Flight is not a question of speculation: it is a certainty, as every aeroplane sold by the BRITISH and COLONIAL AEROPLANE COMPANY IS GUARANTEED TO FLY.

In the event, the brochures produced turned out to be unduly optimistic, not to say foolhardy, in their promises, since the aircraft was unfortunately a complete failure, ignoring all attempts to persuade it leave the ground, and no time was lost in abandoning the project.

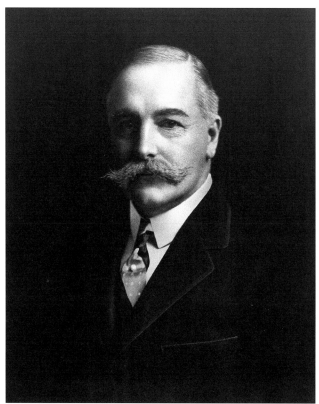

Sir George White, the founder of the British and Colonial Aeroplane Company.

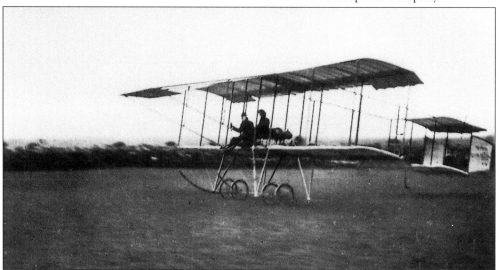

The association with the Zodiac project having been brought swiftly to an end, the Company lost no time in putting this initial setback behind it. This unsuccessful early attempt at Anglo-French cooperation was then replaced by the first truly Bristol design, famously dubbed the "Boxkite". By contrast with the Zodiac, the new venture proved itself a successful flying machine, and in November 1910 confidence in it was such that a demonstration was arranged on Durdham Down, Bristol, where the French pilot M. Maurice Tétard made several flights in one of a number of Boxkites which had by then been constructed.

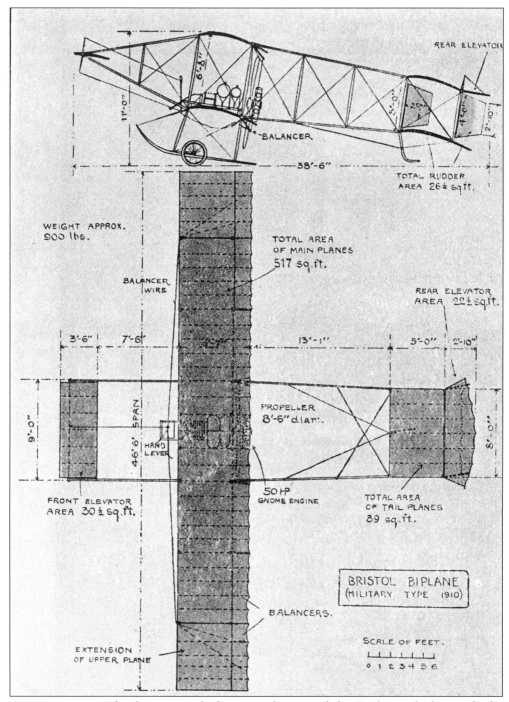

A contemporary side elevation and plan view drawing of the Boxkite, which reveals the sensible simplicity of its design.

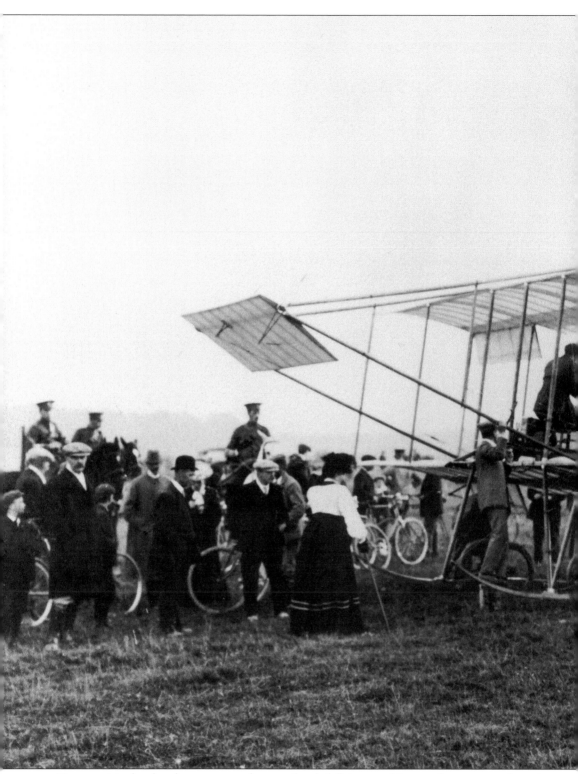

Not surprisingly, the chance to see the new-fangled flying machine at close quarters brought

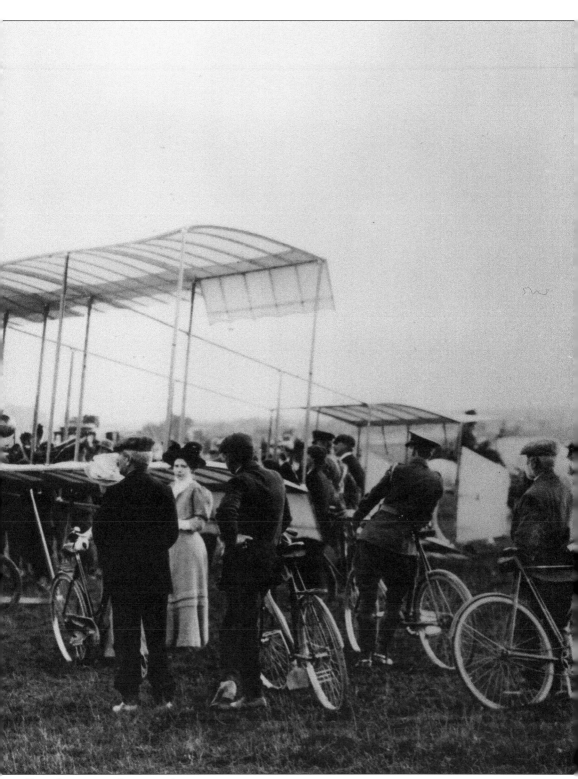

Bristolians out in large numbers.

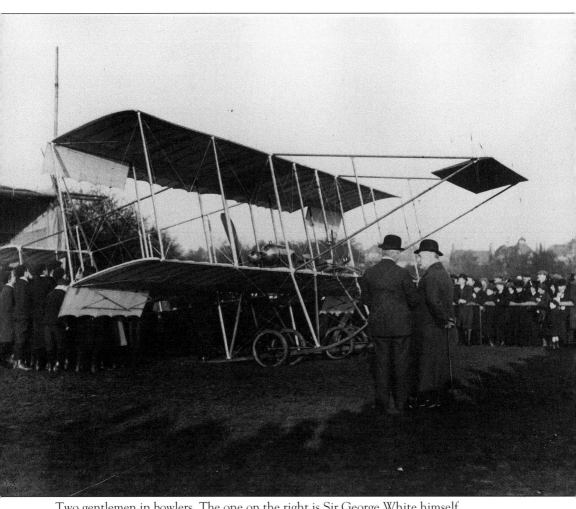

Two gentlemen in bowlers. The one on the right is Sir George White himself.

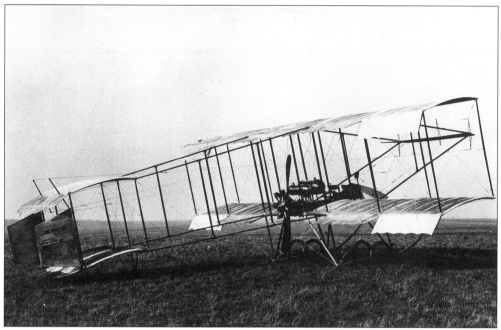

A large number of Boxkites were produced. This one was allocated the serial number 12.A (shown on its fin), having followed number 12. The next to be made was number 14 – the new technology was taking no chances with superstition !

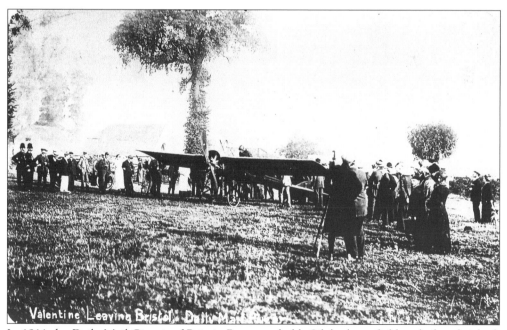

Valentine Leaving Bristol. Daily Mail Race

In 1911 the Daily Mail Circuit of Britain Race was held. Of the large field, only four finished, 1st and 2nd being the Frenchmen Conneau and Vedrines. The English pilot Valentine, well behind them in third place, is seen here about to leave the grounds of Conygre House.

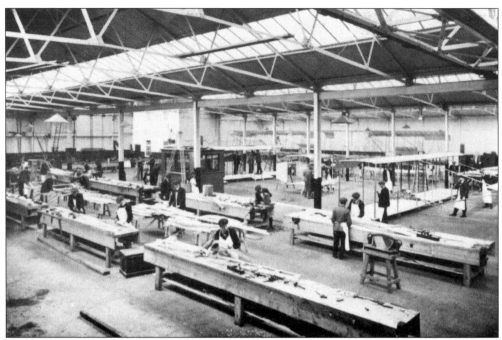

Here, inside the Filton workshops, Boxkites are being assembled while, on the long benches in the foreground, carpenters are forming their wooden components.

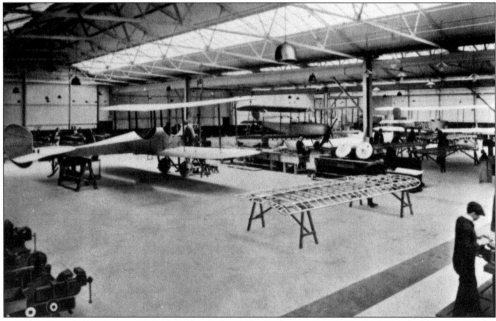

A Filton workshop at a somewhat later date than the previous picture, probably 1913. The nearly-complete aeroplane in the foreground is a B.E.2, designed not by Bristols but by the Royal Aircraft Factory at Farnborough. The Company negotiated a contract to build a number of these aeroplanes to bolster its income while sales of its own aircraft were experiencing a temporary lull. The other machines in the background belong to a range designed for Bristols by the Rumanian Henri Coanda, in 1913-14.

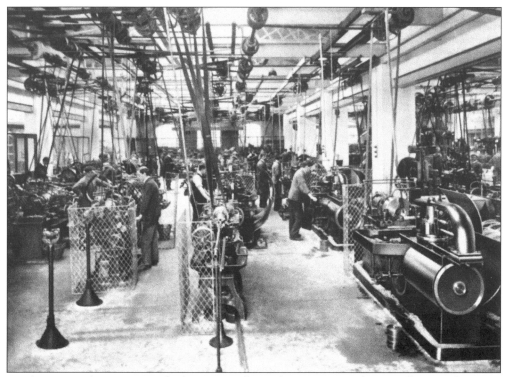

By this time, the Company had grown sufficiently to warrant the installation of a quite substantial Machine Shop.

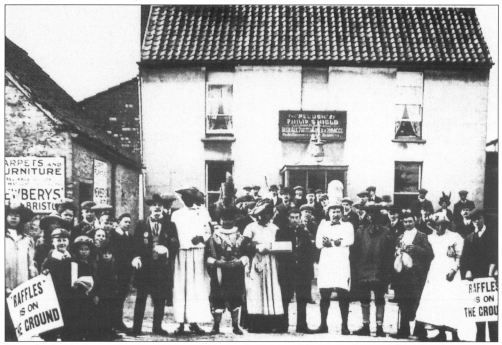

Outside the factory premises, Filtonians went their way. Above, in front of the Plough, a motley crowd are up to something, but the message on the two posters is enigmatic.

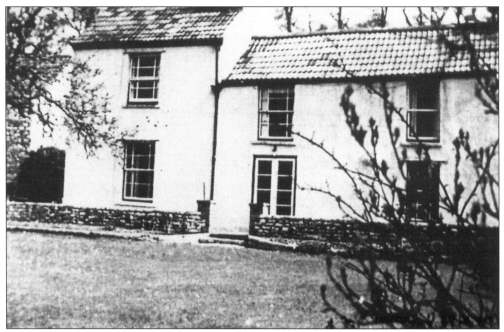

Inevitably, as the factory and airfield made more demands on the surrounding space, once-private dwellings found themselves taken over and either used as offices or demolished. Cherry Rock, later called Westwood Farm, was built in 1905 along Golf Course Lane. It was demolished in 1972.

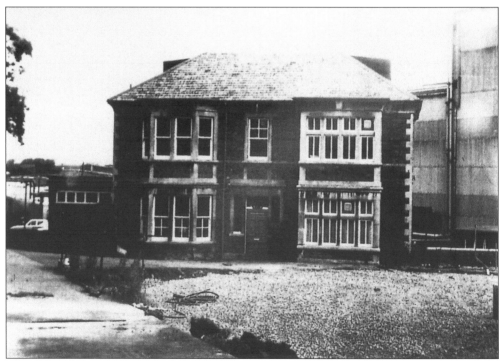

Haycroft House, also built in 1905, lay at the end of a lane, behind Rodney Hall.

Pedrick's Tea Room, otherwise the Coffee Shop, opposite the Anchor.

A summer scene at Haycroft House, when it was still a private residence.

One of the row of houses which formed
Homestead Road, photographed in
1910. It was demolished before the
Second World War to allow the aircraft
company's office block to be built.

Hillside Cottage, photographed in 1963. This, too, later disappeared, to be replaced by a B.Ae.
car park.

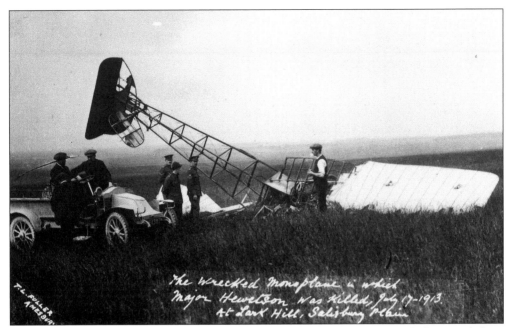

Above and below: Two Bristol-designed aeroplanes came to grief at Larkhill, on Salisbury Plain, where the Company had set up a Flying School. This fatal accident to a Bristol-Prier Monoplane (above) was one of a number involving monoplanes over quite a short period, which led to their being banned for a time by the War Office.

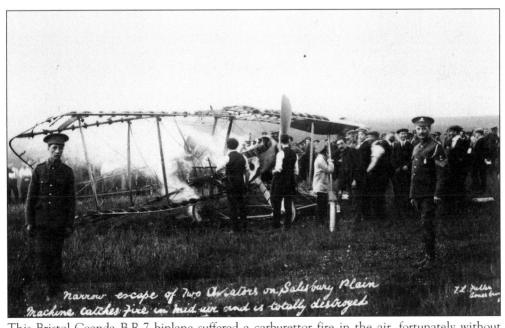

This Bristol-Coanda B.R.7 biplane suffered a carburettor fire in the air, fortunately without harm to the pilot, Collyns Pizey, a former Bristol Tramways apprentice who had progressed to become Chief Flying Instructor of the Bristol Flying School at Larkhill.

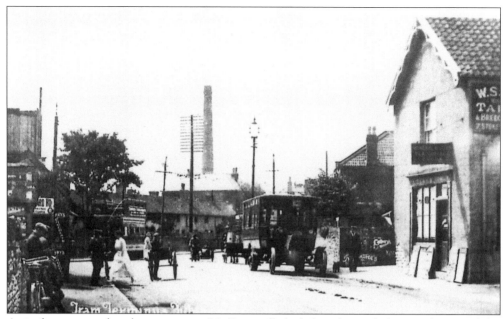

A similar scene to that shown on page 24. Outwardly little has changed; the omnibuses and the trams are still running, the ladies' hemlines are full, but the year is 1914 and Filton is about to become one of the centres of war production.

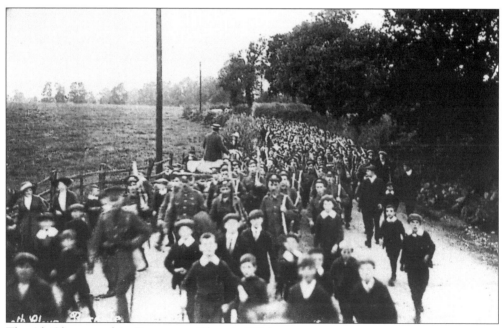

The 6th Gloucestershire Reserves at Filton in 1914.

By the time war came, Boxkites were being manufactured in considerable numbers for both the Royal Flying Corps and the Royal Naval Air Service. Other more advanced designs, such as the nimble Scout, were also being produced and the Filton factory was on the brink of its first expansion. At the outbreak of war, 200 people were already employed by the new company; by the time the Armistice was signed, this number had risen to 3,000.

In 1914, Frank Barnwell had already established himself at Filton as a designer of merit. When the war came, he joined the RFC and saw action in France as a pilot. However, in 1915 he returned, on indefinite leave, to his drawing board in Filton, where his talents could be used to greater effect. He was unfortunately killed in 1938, test-flying a light aircraft which he had designed for his own use.

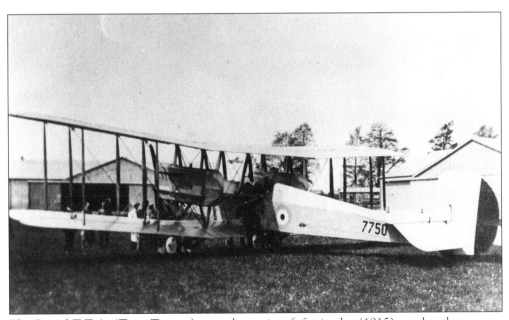

The Bristol T.T.A. (Twin Tractor) was a large aircraft for its day (1915), produced to meet a requirement for home defence. It failed to gain official approval, however, and only two were built.

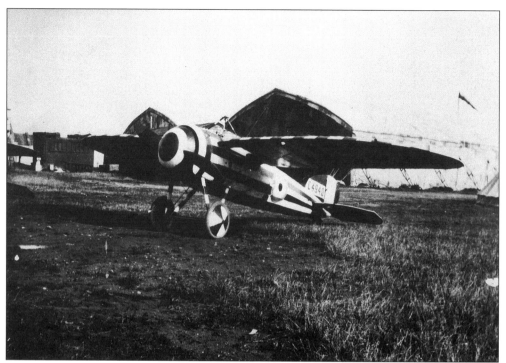

By 1916, the ban on monoplanes had been lifted and the M.1C Monoplane Scout, designed by Frank Barnwell, was being built in quantity. It saw action with several RFC squadrons, although never on the Western Front.

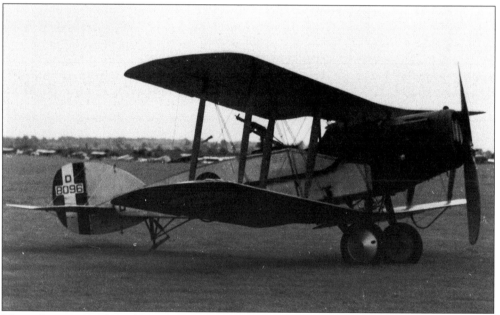

The culmination of Frank Barnwell's work in those wartime days was the highly successful Bristol F2B "Fighter", which combined the two-seater concept, with the observer's rear-facing machine gun, and the high manoeuvrability of the single-seater, with fixed forward-facing armament. Over 5,000 were eventually built.

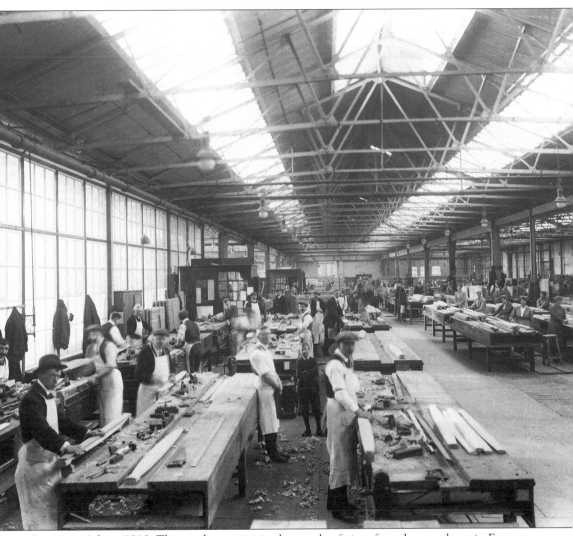

Carpenters' shop, 1918. The need to maintain the supply of aircraft to the squadrons in France and elsewhere filled the workshops with men and women, many of whom were learning new skills.

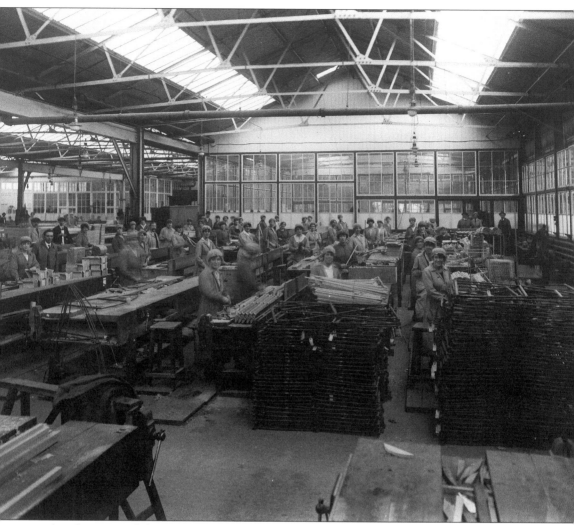

Another part of the Carpenters' shop. An innovation for those days was the large-scale employment of women in engineering work such as aeroplane manufacture. However, a cautious management seems to be operating a policy of segregation of the sexes...

Three
Between the Wars
Industrial Expansion

After the war to end wars, disarmament was the watchword and, as always when Peace seems to be eternal, the fighting services were severely pruned. Many RAF Squadrons were disbanded and the young aircraft industry, only recently working at full pitch to maintain the supply of fighting machines, suddenly found orders sparse and the factory floor empty. Naturally, thoughts turned to the burgeoning promise offered by civil aviation. At first, existing military designs, their original requirement having disappeared, were converted for peaceful use as the first airliners. The Braemar triplane had been designed and built in 1918, in response to a demand for a heavy bomber, to reply in kind to German Zeppelin raids on this country. The project having been overtaken by the Armistice, the third Braemar was converted for passenger carrying and renamed the Pullman.

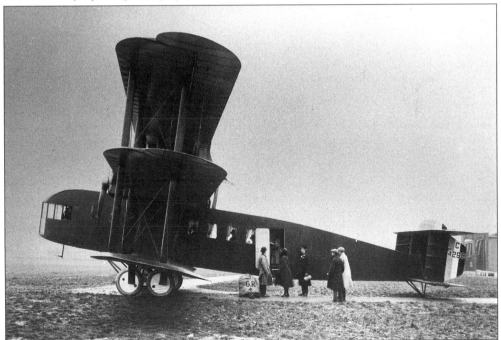

The well-heeled (14 passengers) and the Royal Mail comprised the intended payload of the comfortably-proportioned Bristol Pullman, but the idea was not proceeded with and no more were built.

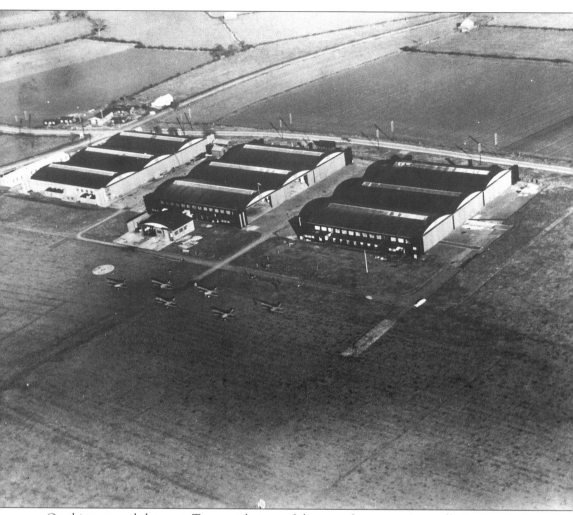

On this page and the next: Two aerial views of the aircraft company's installations soon after the end of the war. These three hangar blocks at Patchway are, for the moment, still standing. The single-carriageway Gloucester Road lies behind them, Gipsy Patch Lane, with open fields on either side, runs towards the top of the picture, while the beginning of Hayes Lane, leading to Charlton village, can be seen just beyond the left-hand hangar.

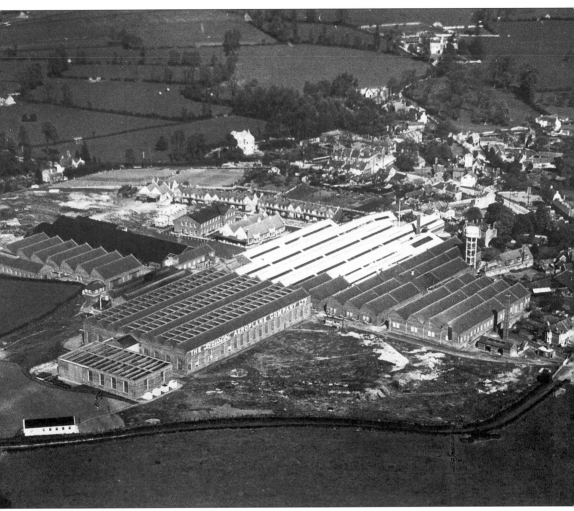

On the southern side of the airfield, the considerable area already occupied by factory buildings testifies to the volume of work being undertaken by the time hostilities came to an end. Golf Course Lane runs along the bottom of the picture, while the houses lying across the centre of the photograph are those in Fairlawn Avenue.

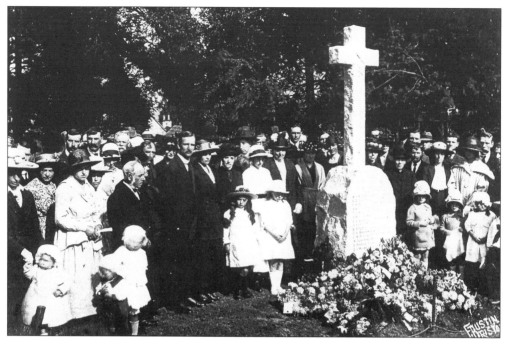

Meanwhile, life on the ground pursued its course. Filton War Memorial was consecrated in August 1920.

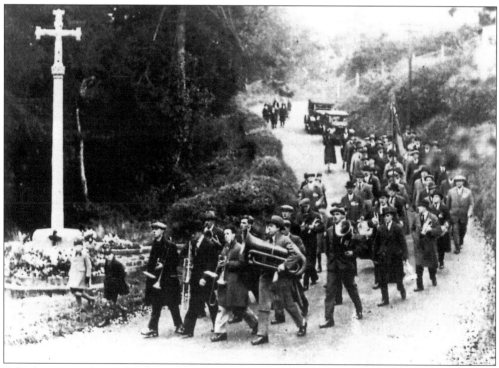

A little way up the road, Filton Band (seemingly somewhat depleted since 1908) march down to take part in the ceremony at Almondsbury War Memorial.

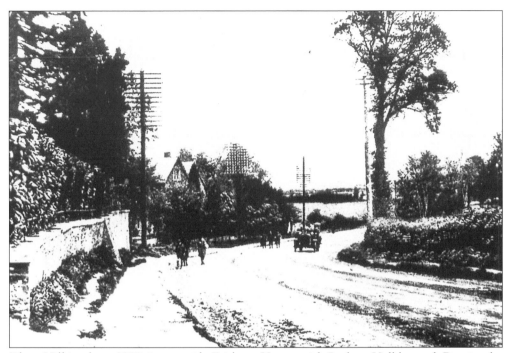

Filton Hill in about 1920, just outside Fairlawn House, with Rodney Hall beyond. Despite the technological changes which were starting to gather pace, the village itself was changing only very slowly. Compare this with the photograph on page 9.

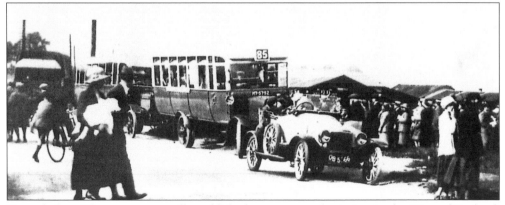

Nevertheless, Filton was now well established as a centre of aviation in the West of England. Here, spectators are seen arriving at the aerodrome by car and bus for another Round Britain Air Race, on 9th September 1922.

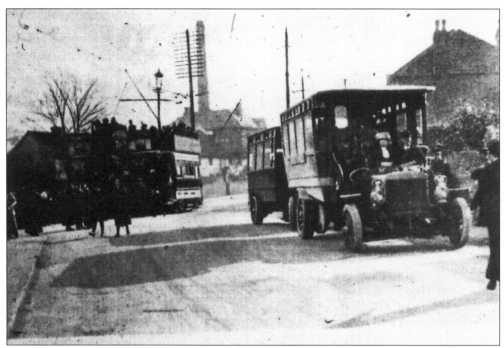

Filton tram terminus in the 1920s. The trams have come out from Horfield, while the buses are due to depart for Thornbury.

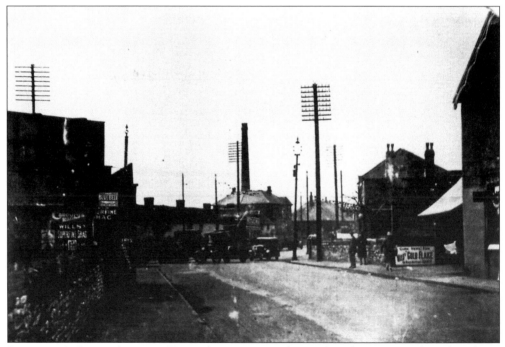

See page 40. Scene: the same. Time: about ten years later. The advertisement hoardings have been changed, but tram design has not. Samuel Shield's laundry chimney still points to the sky, and the outline of The Rank can be seen.

The row of ten terraced cottages known as The Rank. They lay on the other side of the road opposite Filton House, and next to Samuel Shield's residence (now Lloyd's Bank). They were demolished in the late 1930s and replaced by the present parade of shops.

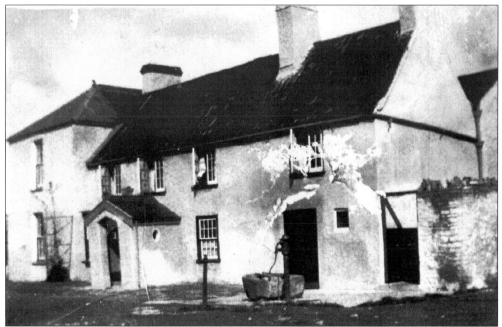

The New Inn, Patchway, in 1923. Subsequently considerably altered, it was then with us for a number of years in the guise of the Traveller's Rest. Recently, however, this name too was dropped and, perhaps to meet the mood of the times, it now rejoices in the name of "The Hungry Horse".

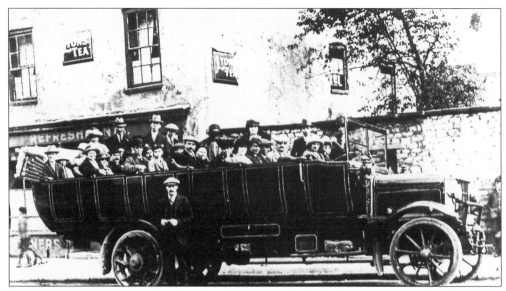

A party prepares to set out for Portishead from outside Pedrick's tea room in the Gloucester Road, in 1926.

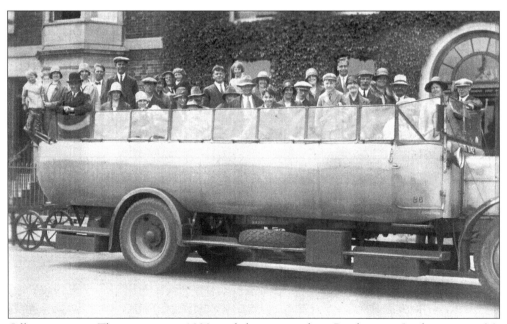

Off we go again. The year is now 1928, and the party is from Patchway ... In the interim, Mr Dunlop's invention has arrived to ensure us a more comfortable ride.

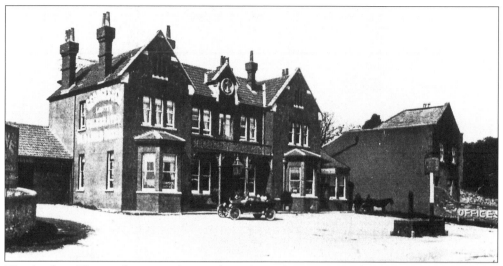

The Anchor. This inn has existed since the eighteenth century. As later photographs reveal, it was subsequently extended on the left by the addition of a third gable.

The Anchor today. No more cakes and ale...

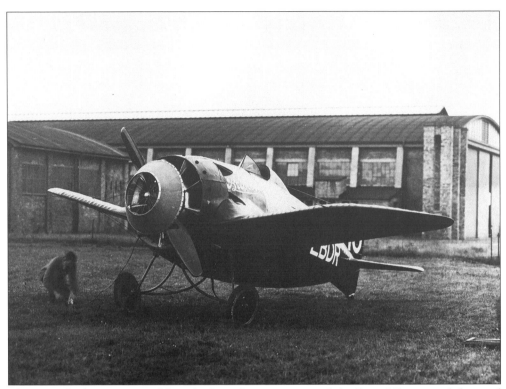

This aircraft, despite its unathletic-looking shape, was named the Bristol Racer, and designed specifically around a new Bristol engine, named the Jupiter (510 hp). It was, however, doomed by fundamental design problems and abandoned after only the prototype had flown.

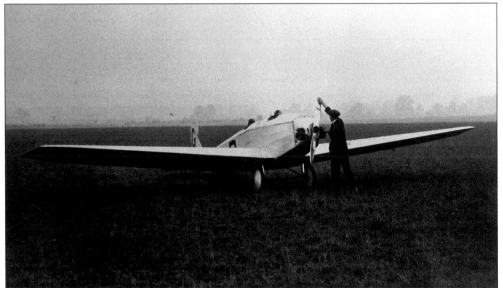

"Switches off... Contact!" Swinging the propeller on the Bristol Brownie. This small aircraft, designed by Frank Barnwell, was built in 1924 and entered in the Light Aeroplane Trials at Lympne that same year. Although it gained second prize, it found itself in direct competition with the superlative de Havilland Moth, and only three were built.

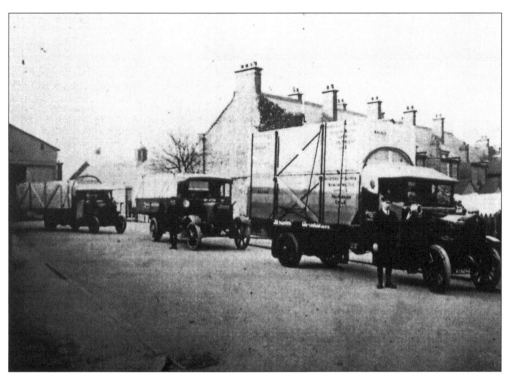

Lorries loaded with aircraft parts wait in Homestead Road while their drivers pose for the photographer. Behind are the houses of Fairfield Avenue, still privately occupied.

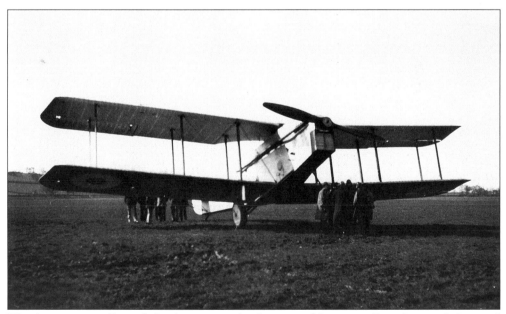

Warplanes were still needed, of course, and, after some false starts, Bristols recorded several notable successes in this field. The Bristol Berkeley flew in 1925, in response to an Air Ministry specification for a two-seater bomber. Official approval, however, was not forthcoming and only three were built. An impromptu design meeting seems to be taking place by the nose.

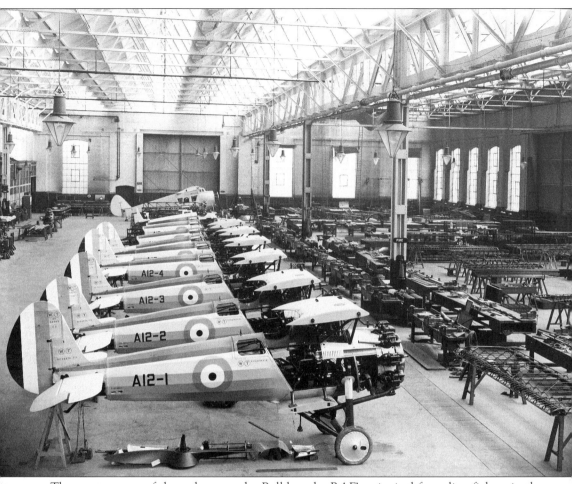

The great success of those days was the Bulldog, the RAF's principal front-line fighter in the early 1930s. A Bulldog production line in October 1929. Gradually the firm expanded again.

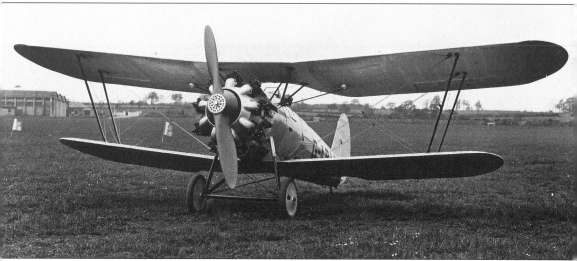

A Bristol Bulldog at Filton in May 1930.

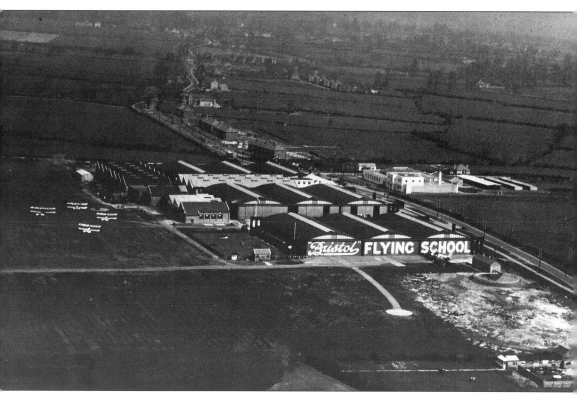

Meanwhile, changes were gradually taking place on the ground. In this picture, the Company's first expansion on the eastern side of the Gloucester Road has begun and some more building has been undertaken around the hangars pictured on page 46. Bristols, in common with other aircraft companies, ran one of the many "Reserve Flying Schools", which had been set up by the Air Ministry for the training of "weekend pilots" in what was then the RAF Reserve (this one was later designated N° 2 EFTS). Beyond, just a few houses are scattered here and there in the green spaces which today are covered by Patchway's housing estates.

Lunch-hour. Once again, the Bristol Aeroplane Company found itself recruiting more workers. In 1918 the payroll had reached 3,000. By the end of 1935 it had risen to over 8,000. This view was taken some years after that on the previous page, looking in the opposite direction. Crowds of the company's employees are streaming out of the workshops and offices and walking along the middle of a remarkably traffic-free Gloucester Road to the canteen on the corner of Gipsy Patch Lane. (Hayes Lane is to the right).

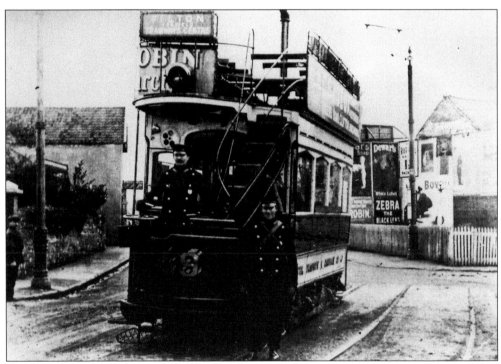

Reflecting these changes, the population of the parish of Filton grew too: from 658 in 1911, it had reached 3,230 by 1931. The farming village had changed irrevocably. No longer so much in and of the countryside, it now looked toward the town. At "knocking-off time", the employees of the Bristol Aeroplane Company emerged from the factory gates in large numbers, bound for home. The trams were then still very much in evidence. It was 1939 when they were finally withdrawn from service.

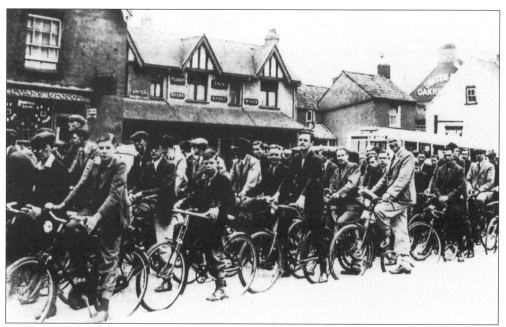

Good news for cycle clip manufacturers. Outside The Plough in 1930. The massed crowd of cyclists is also, presumably, leaving the Aeroplane Company at the end of the day's work.

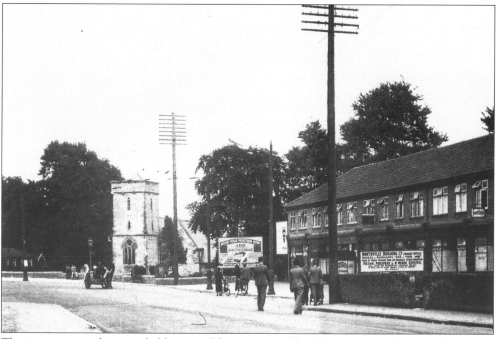

The incoming workers needed houses. Of course, not all of them came to live in Filton itself, but most chose to live not too far away. As house-building boomed, the acres of farmland shrank, Filton spread and, like adjoining districts such as Horfield, Henleaze and Southmead, it gradually became, in effect although not in name, an outer suburb of Bristol. This shot was taken in 1935, just opposite the main factory gate. Just £350 for a whole house? Truly another world!

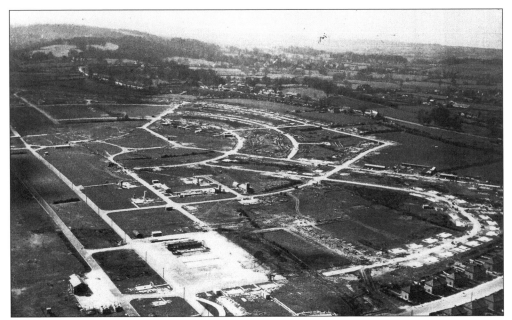

In next-door Southmead, more houses were going up, as new estates overpowered the grassland. Work began in January 1931 and was half-completed by 1939, when it was interrupted by the war. In fact, the two aerial views on this page illustrate the second, post-war phase, when activity continued apace. A small part of the earlier development can just be glimpsed on the extreme right of the second picture. See also the aerial view on the frontispiece. Above, looking west towards Coombe Hill, the long straight line of Greystoke Avenue can be traced on the far left, with the distinctive pattern of the subsidiary roads beyond.

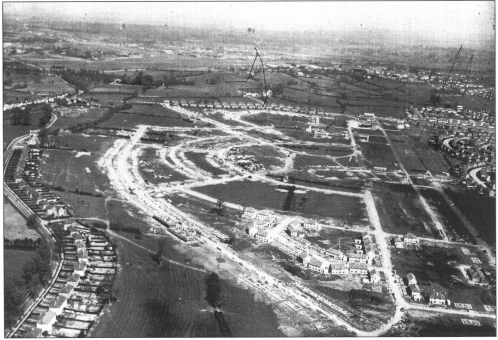

Looking north-east: Filton and its airfield lie in the middle distance.

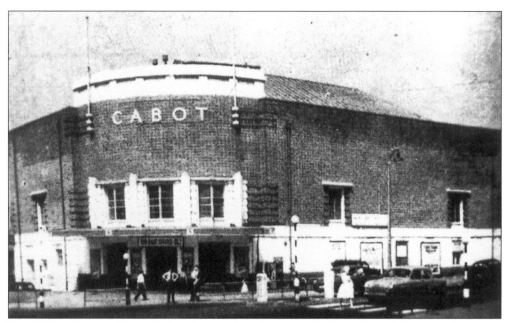

The Cabot Cinema, Filton Park, a landmark and a mecca for a quarter of a century. It opened its doors on the 26th October 1935 and closed in 1961. After service as a supermarket, it has now gone completely.

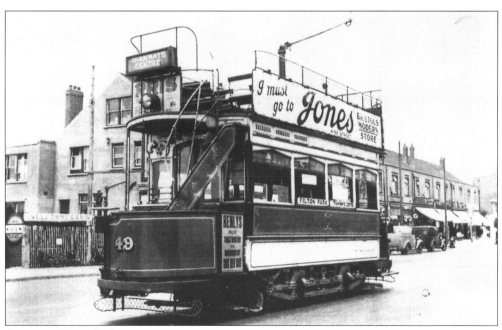

A tram at Filton Park.

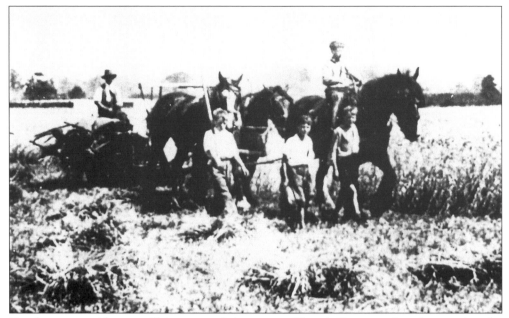

Yet the countryside was still just around the corner. Church Farm continued to survive the changes, as did Filton Hill Farm, where Farmer Saunders can here be seen with his four sons harvesting barley.

Haymaking on Patchway Common in the 1930s. Left to right: Ernie Robbins (with horse), Frank Webber, John Webber, Mary Hayward (from Albion Terrace), Winnie Phillips (behind, from The Avenue), Gwen Sharp (?), Ivy Sharp (?), Mary Frost, Joyce Laird (from Hempton Lane), Myrtle Hunt (in hat), Howard Woodman (on top), Jim Woodman (bending over, from Primrose Cottage).

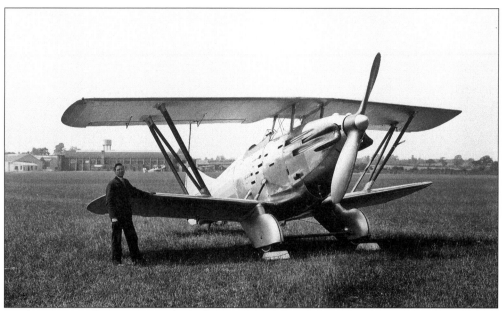

By the 1930s, military aviation had all but evolved from the "stick-and-string" technology of 1914-18. All-metal "stressed-skin" structures were becoming general, more powerful engines were being developed and, thanks to advances such as these, the armaments which could be lifted into the air were becoming more powerful. These two Bristol "Four-gun Fighters", Types 123 and 133 respectively, produced to respond to the same Air Ministry Specification of the early 1930s, represent a distinct stage in the advance from the underpowered, lightly armed "scouts" of the late war to the eventual arrival of the eight-gun Spitfire and Hurricane fighters of the Battle of Britain.

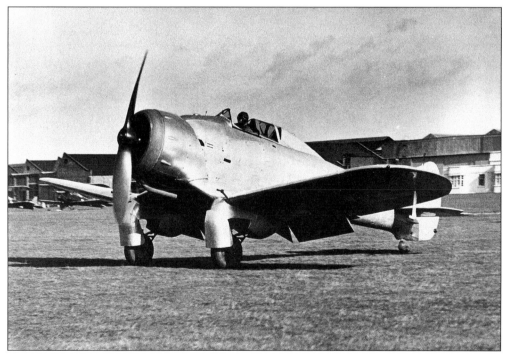

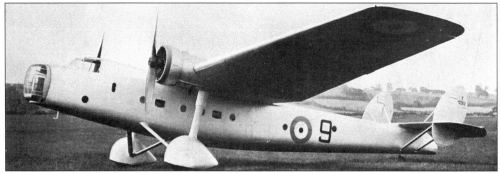

The Bristol 130 prototype in 1935, designed as a Bomber-Transport and later named the Bombay. Archaic by the time the war arrived, it was extensively used as a troop transport.

As well as being an airframe manufacturer, Bristols had, of course, also been a designer and manufacturer of aero-engines since 1920, when it acquired the Cosmos Engineering Company, based at Fishponds. Thus, under the leadership of Sir Roy Fedden, was born the famous range of Bristol air-cooled radial engines, culminating in the sleeve-valve series which included the Perseus, the Taurus and the Hercules.

Sir Roy Fedden was Technical Director of the Cosmos Engineering Company when it was taken over by Bristols, and continued at Filton in a similar capacity for many years.

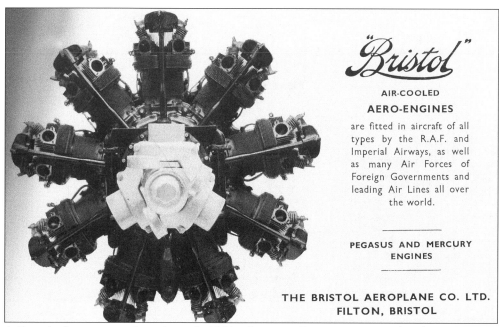

A Bristol advertisement from the early 1930s, showing a Pegasus engine in detail.

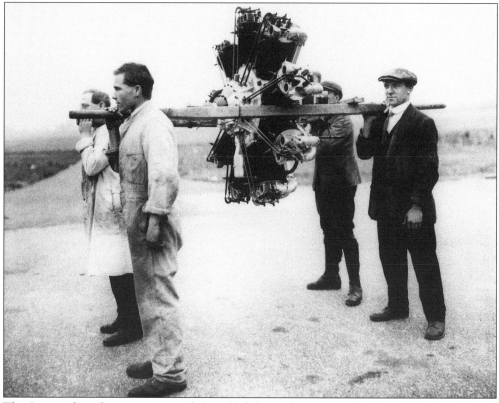

The Jupiter, here being transported the old-fashioned way, was the first of the long line of Bristol air-cooled radial engines.

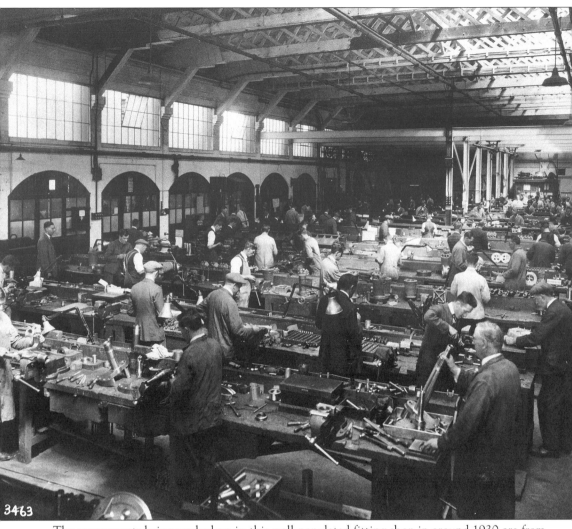

The components being worked on in this well-populated fitting shop in around 1930 are from Jupiter engines.

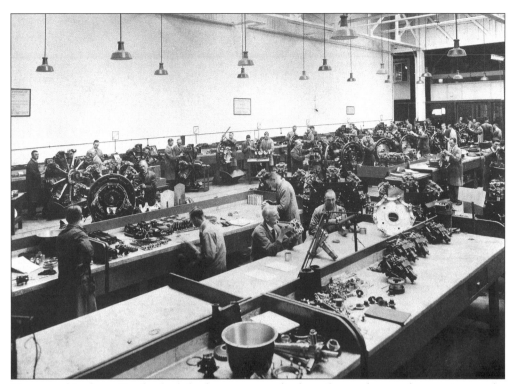

The assembly shop. On the far left, the separate cylinders of a nearly-complete engine can be seen. The many precision-machined parts which were required to be assembled into an aero engine represent a far cry from Thomas Iles' smithy or Robert Phillips' coach-building shop, not so very many decades earlier.

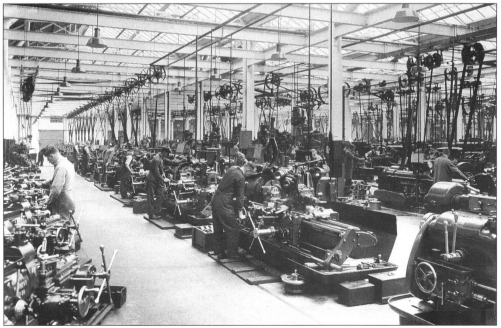

Nº 1 Machine Shop.

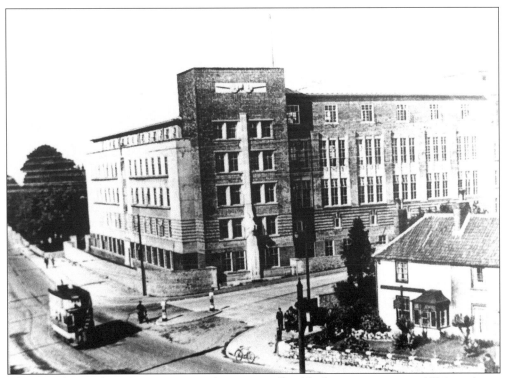

The Bristol Aeroplane Company's new five-storey office block came into use in 1936, evidence of the flourishing nature of its affairs.

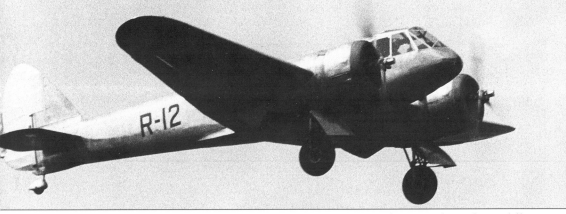

With the advent of Adolf Hitler and German rearmament, Bristols was ready to play its full part when the Royal Air Force was required to expand once more, in preparation for another European war which everyone still hoped would never come. By 1937, however, the writing was on the wall. In open defiance of the Versailles Peace Treaty, Germany was producing large numbers of highly efficient warplanes which were already demonstrating the effectiveness of modern airpower in the skies over Spain. The Bristol Type 143, patriotically named the "Britain First", was built in 1935 for Lord Rothermere, the owner of the *Daily Mail*, as his private transport. It was soon realised, however, that it would also make an effective light bomber. It was noted, furthermore, that it was considerably faster than the outmoded biplanes then equipping all the RAF's frontline fighter squadrons!

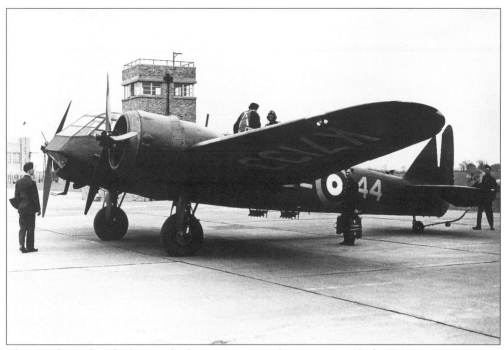

Thus was born the Blenheim, which went into squadron service with the RAF in 1937. Here, a Mark I (the "short-nosed" version) is being prepared for flight. Its descent from Lord Rothermere's "Britain First" is unmistakable.

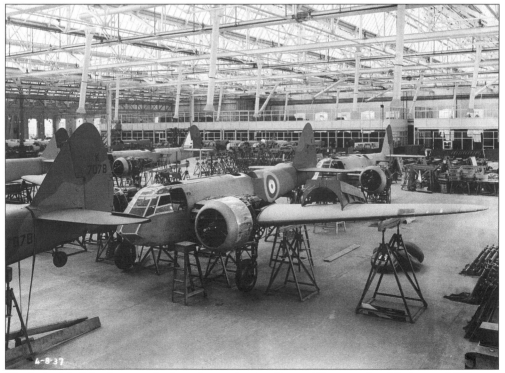

Blenheim Mark Is photographed on the production line at Filton on the 4th August 1937.

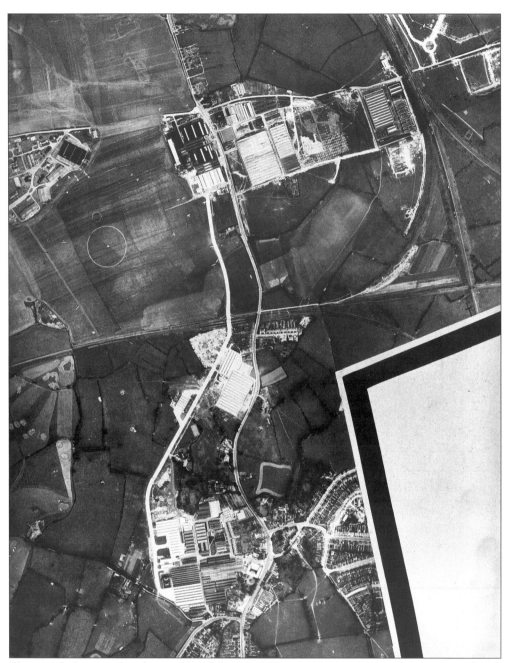

This aerial photograph, taken on 21st February 1939, provides us with much interesting detail. The RAF site is on the left. Hayes Lane, which used to run from Patchway to Charlton, has been severed to allow extension of the airfield northwards. The Patchway factory has started to expand along the southern side of Gipsy Patch Lane, but fields, enclosed by hedgerows, still cover quite large areas around the two villages (Filton Hill Farm, with its fields behind it, lies immediately opposite the engine company's Rodney Works, south of the railway line). The airfield is still all-grass; the first hard runways were not laid until 1941/42.

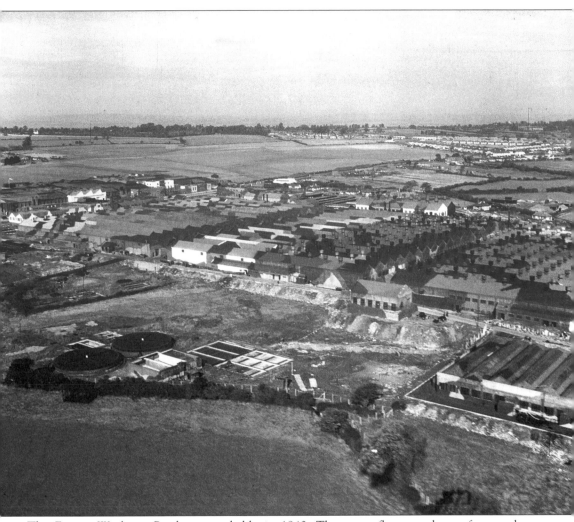

The Engine Works at Patchway, probably in 1940. The camouflage on the roofs proved, unfortunately, to be ineffective. In the distance, some of Patchway's new housing.

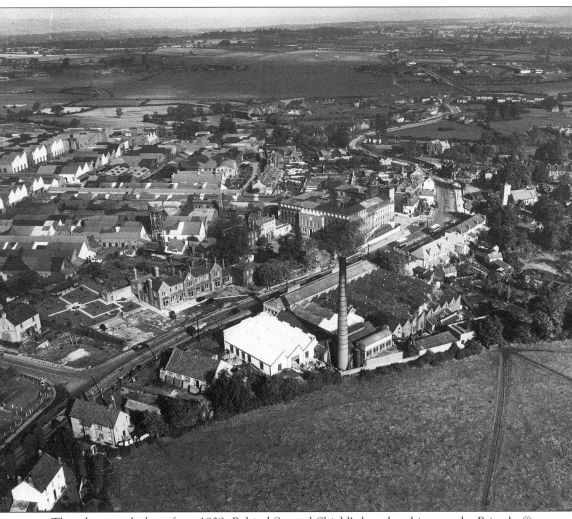

This photograph dates from 1939. Behind Samuel Shield's laundry chimney, the Bristol office block has been camouflaged. The Gloucester Road winds its way down Filton Hill, passes through Patchway and disappears into the distance. The Anchor, with its extra wing, has a pleasant formal garden alongside. The washing lines in Fairlawn Avenue seem to proclaim that it is a Monday!

Four
Conflict Returns

On a sunny Sunday morning, at eleven fifteen on 3rd September 1939, wireless sets all over the country, relaying the voice of Neville Chamberlain speaking "from the Cabinet Room of Number Ten Downing Street", confirmed to the nation that of which it was already certain – Great Britain was once more at war with Germany. By then, the Filton workshops were committed to a full production programme of Blenheims, with manufacture of the later Beaufort bomber and of the highly successful Beaufighter in its early stages.

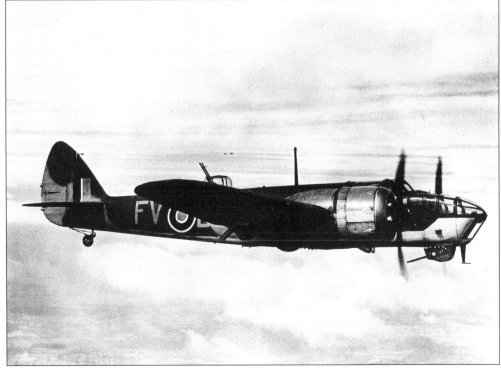

The Blenheim Mark IV, or "long-nosed" Blenheim to distinguish it from the Mark I, the next in line of descent from Lord Rothermere's "Britain First".

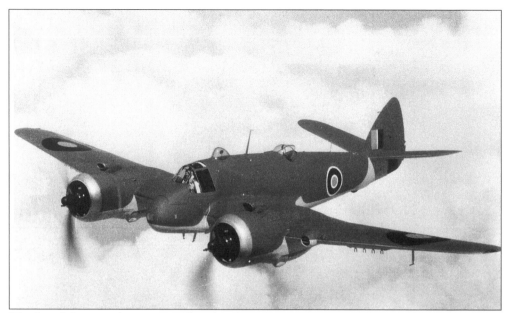

The Beaufighter Mark X. Equipped with airborne interception radar, the Beaufighter made its mark as a night fighter. The version in the picture, however, carried a torpedo for anti-shipping strikes, like its sister, the Beaufort.

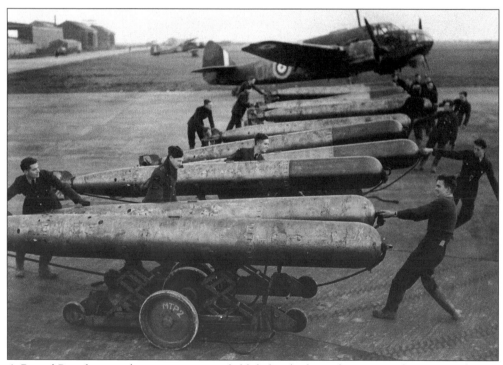

A Bristol Beaufort stands on a wartime airfield, behind a line of its principal weapons, the air-launched torpedo.

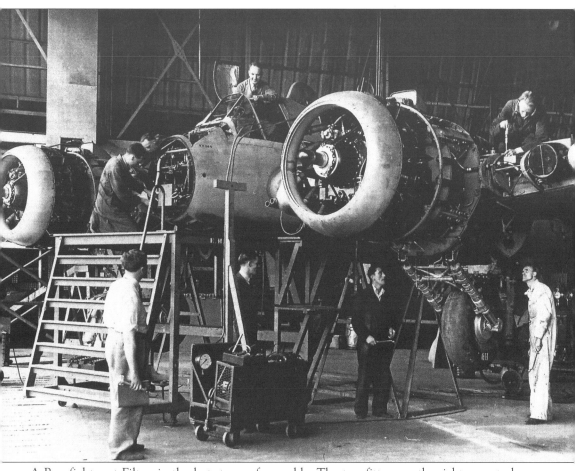

A Beaufighter at Filton in the last stages of assembly. The two fitters on the right seem to be testing the undercarriage retraction while, on the left, an inspector is recognisable by one of the tools of his trade, a torch. All are very properly uninterested in the presence of the photographer...

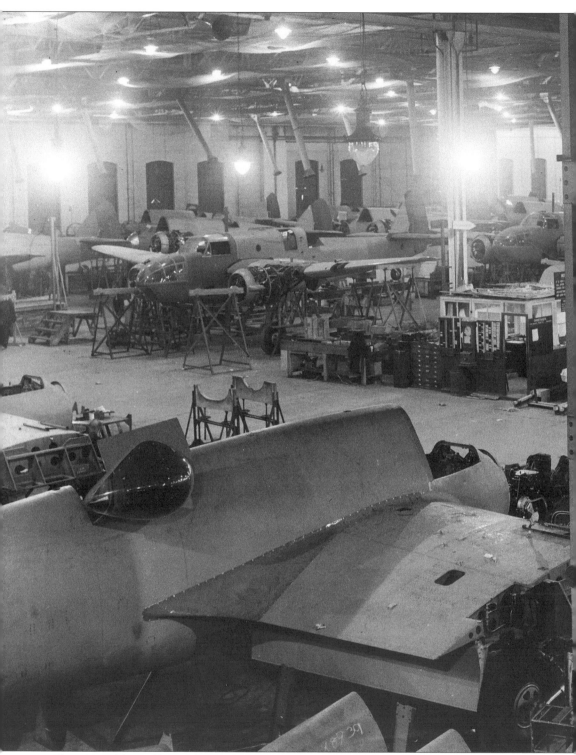

The Assembly Hall at Filton in March 1941. A half-finished Beaufighter occupies the foreground, while the remainder of this night-time scene is filled with Beauforts in various

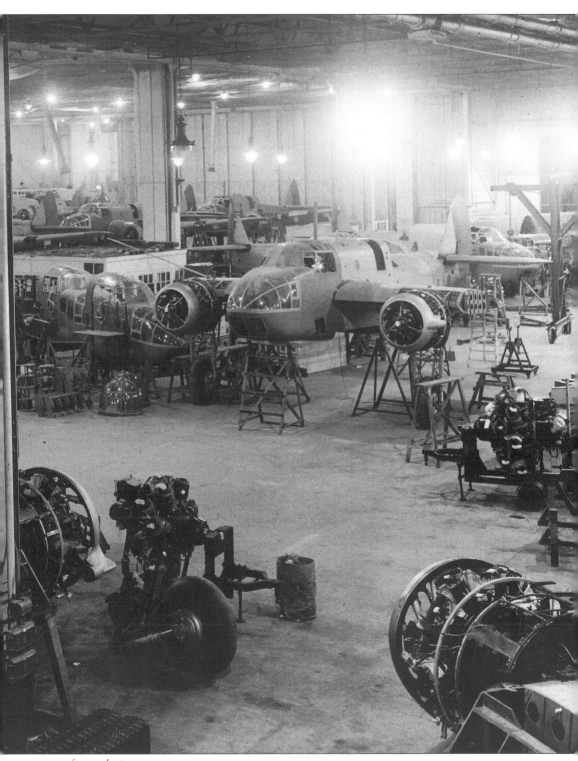

stages of completion.

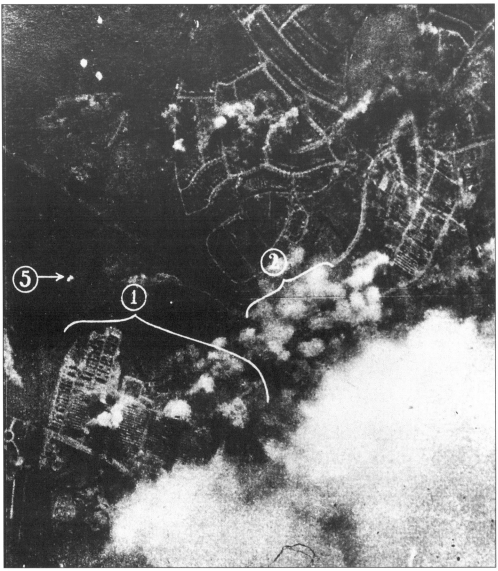

On 25th September 1940, Filton suffered its worst air raid of the war. Heinkel He111s pierced the defences (there was no fighter squadron based at Filton at the time – even more pressing business had demanded their presence on the Kent and Surrey airfields) and did considerable damage to the factory as well as causing heavy loss of life (91 people were killed). This photograph was taken from one of the bombers during the raid. Bombs can be seen bursting on the engine factory in Gipsy Patch Lane (1) and on the Rodney Works and Victoria Park (2).

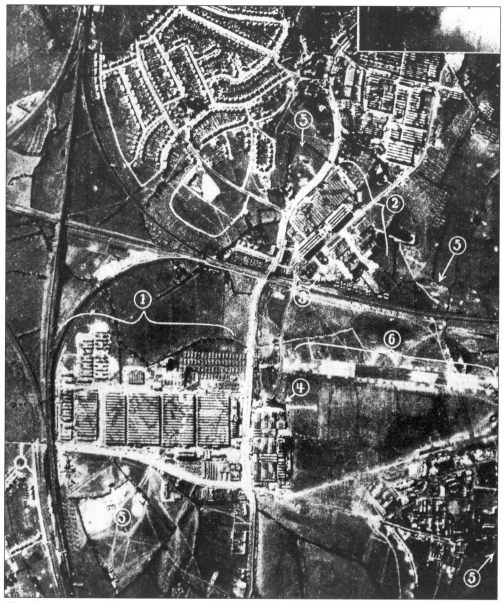

This clearer view of the same area was taken by a reconnaissance aircraft at a later time. South lies at the top of the page in both cases.

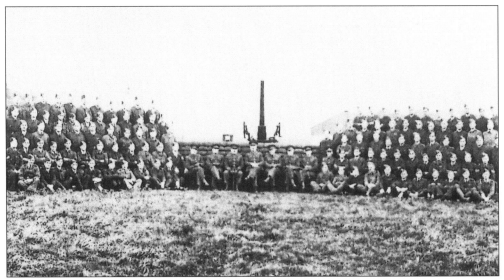

The Bristol Aeroplane Company's own Home Guard unit, assembled for the photographer with military precision at Victoria Park. In 1940, when they had every reason to expect to see action against a battle-hardened and far better-armed German invasion force, some of them might have been dismayed at the derisory epithet of "Dad's Army" which a later, more complacent age was to bestow upon them.

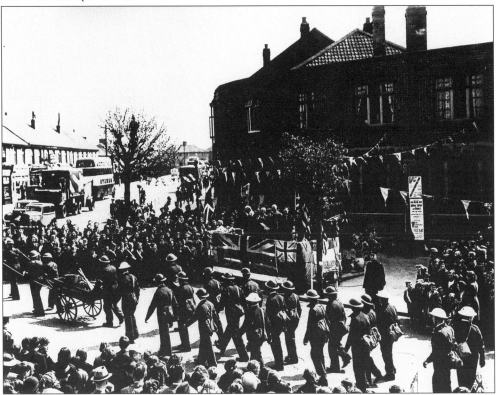

War Weapons Week at Filton, from 10th to 17th May 1941. The Duchesses of Kent and Beaufort take the salute at Filton Park, on the corner of Braemar Avenue.

Venue: the same. Event: Salute to Soldiers Week from 10th to 17th June 1944. Seven bands took part and over £12,000 was raised on the first day.

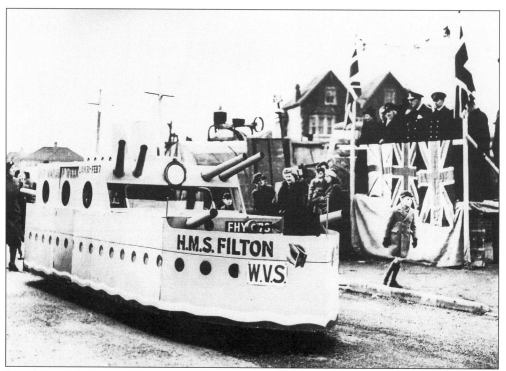

Warship Week at Filton Park. The Navy always christen their shore establishments HMS this or that, but I cannot recall there ever having been an HMS *Filton*!

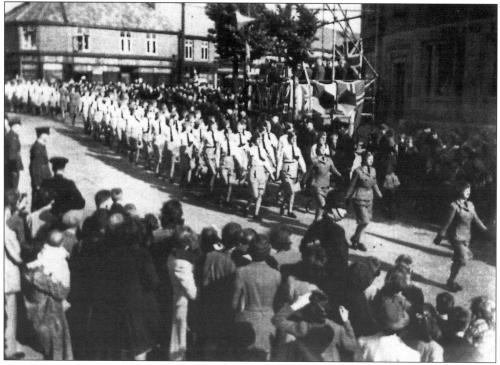

Another wartime parade. This time, the ATS are marching past.

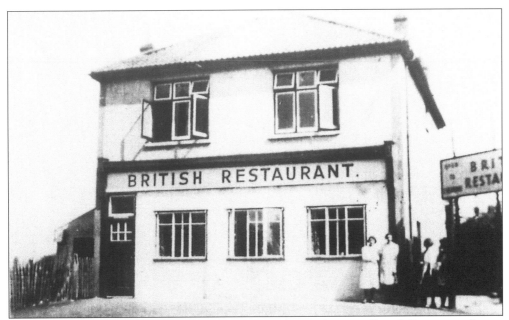

Two ways of tackling the problem of food shortages during the war: "British Restaurants" were opened all over the country in an effort to ensure that nourishing food was available to all. Here, the nation's culinary genius for the production of simple meals of the "meat and two veg. plus pudding and custard" variety could be turned to good effect. This one, in what is now part of Sinclair House, was photographed in 1943.

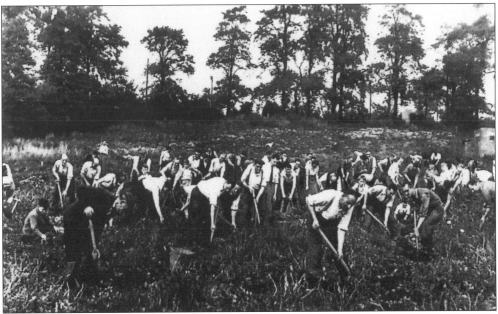

Allotments were quite widely cultivated before the war, but wartime conditions produced a great surge in such activities, urged on by the Government's "Dig for Victory" campaign. The direct result was the formation, after the war, of the Filton Horticultural Society, whose members are seen here digging potatoes at Cherry Rock, on Golf Course Lane in 1946, when food rationing was, of course, still very much on the menu.

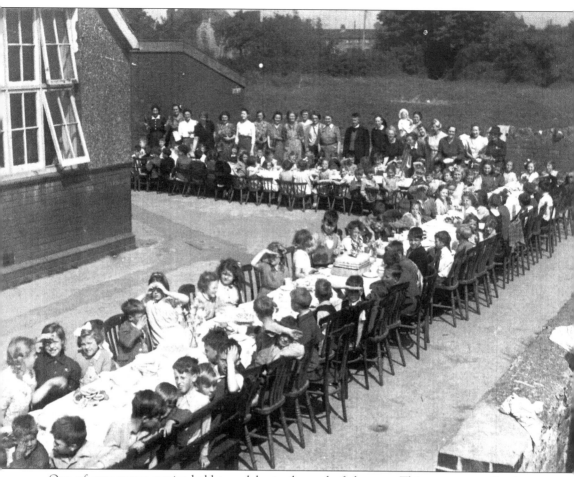

One of very many parties held to celebrate the end of the war. This one was at Patchway School.

Five

Post-War Filton

Once more, the country was at peace. Once more, the Armed Services and those who supplied them with their weapons found their activities severely curtailed. However, this time around, Civil Aviation was at a much more advanced state and offered a promising market. Bristols kept a foot in both camps.

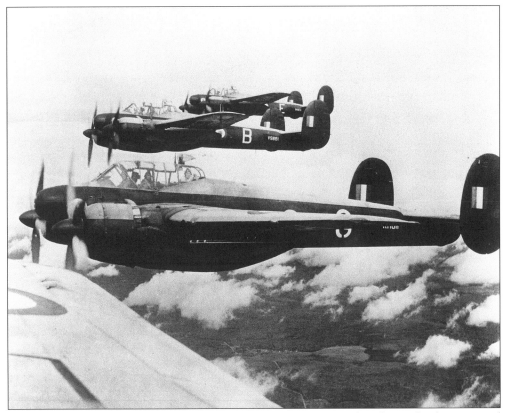

The Bristol Brigand first flew in 1944 and, with its sister, the Buckingham, clearly continued the pedigree which began with Lord Rothermere's "Britain First". Too late for the Second World War, the Brigand nevertheless saw operational service in the Malaysian anti-terrorist campaign.

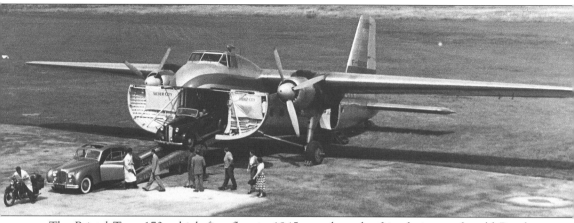

The Bristol Type 170, which first flew in 1945, owed much of its design to the old Bombay troop carrier. Over 200 were built, in either the "Freighter" or the "Wayfarer" version. A special "long-nosed" Freighter (shown here) was produced for Silver City Airways and used for that company's highly successful cross-Channel car ferry service in the 1950s and 1960s. It carried three cars, with a small airliner-standard cabin for passengers. It provided a fast and convenient way of taking a car abroad; unfortunately three vehicles per journey hardly matches today's requirements, when several hundred cars, plus articulated trucks, can be conveyed in a single marine ferry sailing.

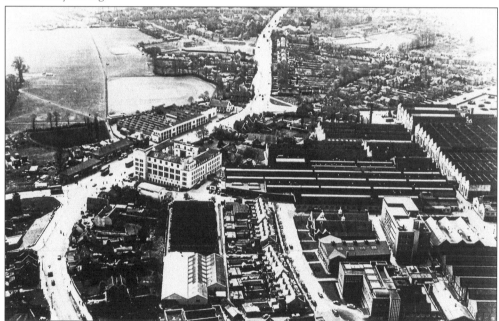

This shot, taken in 1950, is another interesting aerial view, of both the factory and the village. Although the Gloucester Road, still single-carriageway, winds through a very different Filton from the one we saw at the beginning of this book, much yet remains that has now gone. Samuel Shield's laundry has been replaced by Filton Technical College, but green fields still survive behind; beyond is the Memorial Hall, built in 1926/27 in memory of the war dead, but demolished in 1962 to make way for the new Link Road. Across the road, the Anchor still flourishes and still has its garden, while, at the foot of the picture, Fairlawn Avenue remains a residential street, albeit hemmed in by industry.

Filton church in 1949, looking down Church Street towards Conygre Road. The "Hut" is on the left. In the background, streets of new houses have appeared on that part of the parish formerly called Filton Meads.

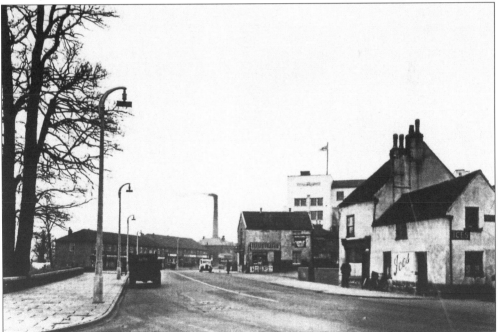

The building on the right was known first as the Hillcrest Café, then later as the White House Café. In the distance, Samuel Shield's chimney remains a familiar landmark.

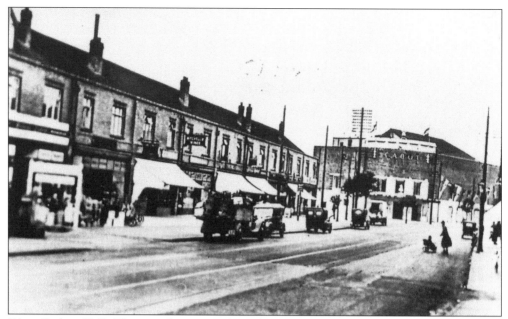

Filton Park in 1949. The trams have gone, but otherwise the scene is little changed from that in the photographs on page 61.

Rodway Road, Patchway, in the 1950s.

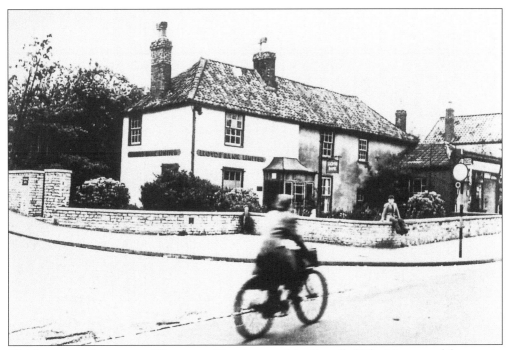

This house, on the corner of Homestead Road, was originally called The Homestead, but was in its latter days occupied by Lloyd's Bank, before it was demolished in the 1950s in favour of a pedestrian subway.

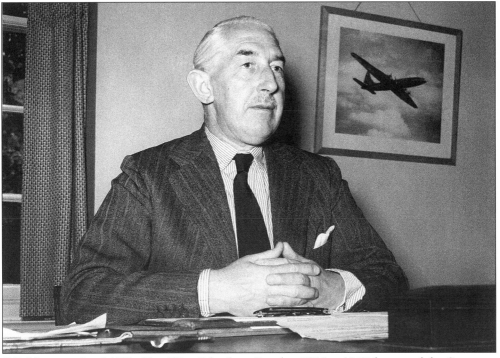

C.F. Uwins in April 1951. Chief Test Pilot from October 1918 to 1947, he served the Company from 1918 to 1964 and his career spanned aviation history from the biplane to the jet.

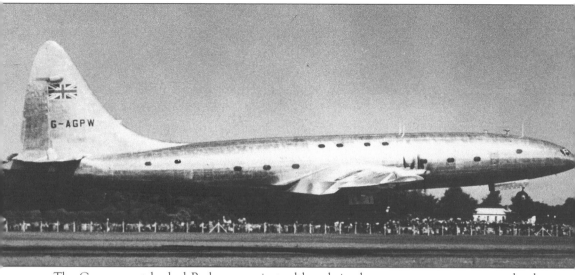

The Government-backed Brabazon project, although in the event not a success, caught the imagination of the time by its sheer size. The idea of a giant eight-engined airliner, designed to cruise non-stop across the Atlantic with 100 passengers aboard, represented, shortly after the war, an exciting technological leap forward and a feather in the nation's cap. Unfortunately, the Americans, with the more workaday Lockheed Constellation and Douglas DC4, chose what turned out, at the time, to be a more practical path. Sadly, only the prototype Brabazon was completed and flew. Watched by a large crowd, the Brabazon I prototype takes off on its first flight from the new Filton runway on Sunday, 4th September 1949.

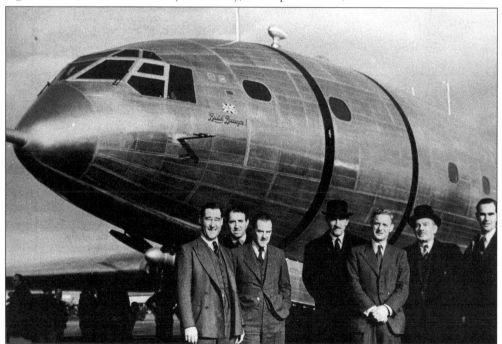

Among this group by the nose of the Brabazon I prototype are Chief Test Pilot A.J. (Bill) Pegg (far left), Chief Designer A.E. Russell (hands clasped) and Sir Reginald Verdon Smith (far right), Director.

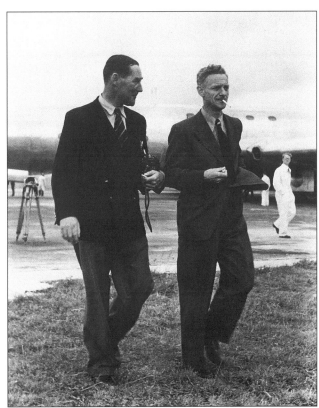

Bill Pegg with "Russ" – A.E.
(later Sir Archibald) Russell.

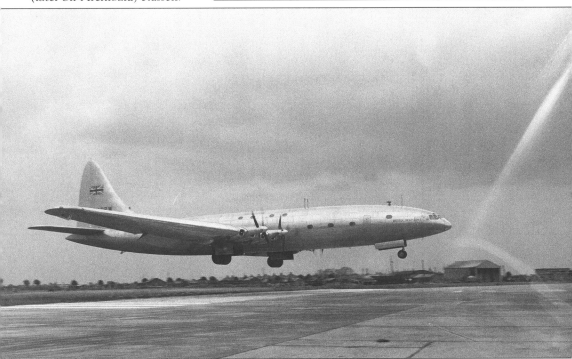

The Brabazon landing at Heathrow during a demonstration flight on 24th July 1951.

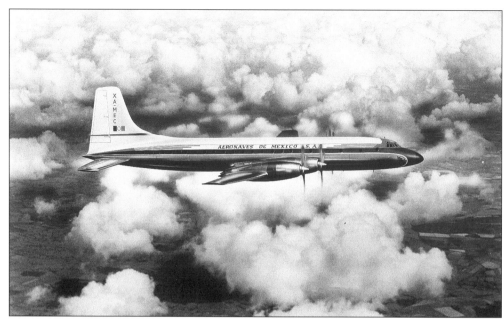

The Britannia first flew on 16th August 1952. Its development was dogged by technical difficulties, including Bill Pegg's celebrated forced landing of the second prototype on the mud of the Severn Estuary on 4th February 1954, and entry into airline service was delayed until 1957. From then on, however, the aircraft was a great success. Some eighty-odd were built and were operated by many airlines, the first being BOAC itself.

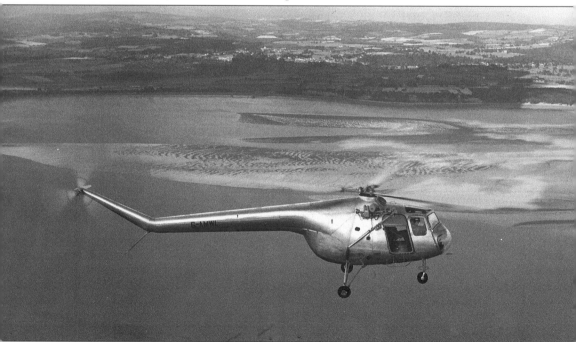

Bristols started to take an interest in helicopters during the war, and the first to be produced was the Type 171, later named the Sycamore. The aircraft illustrated is a Mark 4, in flight over the Severn Estuary.

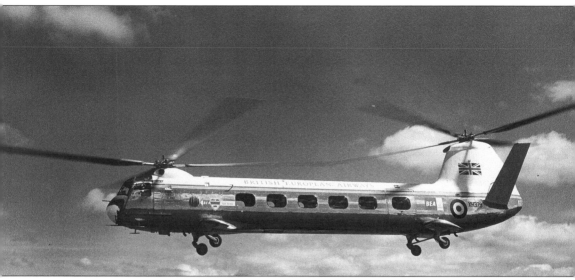

The second and only other helicopter to come from the Bristol design offices and to go into service was the Type 173 Belvedere. Both these aircraft had successful service lives with the Royal Air Force. In 1960, Bristols' helicopter interests were transferred to Westland Aircraft Limited, which is today the only remaining helicopter manufacturer in the British Isles.

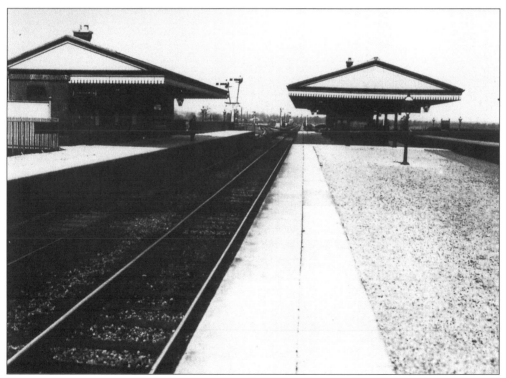

Filton railway station in those days was still styled "Filton Junction" and boasted the traditional buildings, as these pictures from the 1950s show.

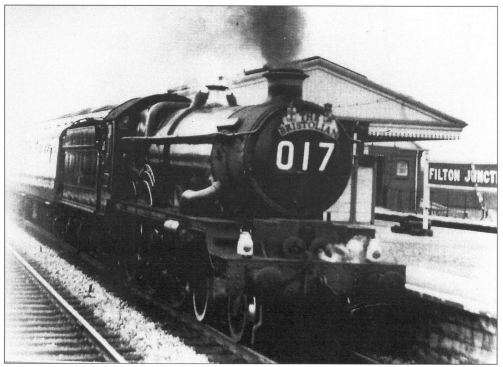

Arrival of *The Bristolian*, drawn by a Castle class locomotive.

This view was taken from the Gloucester Road bridge, looking east. Around the right-hand bend lies Filton Junction; straight ahead leads to Stoke Gifford.

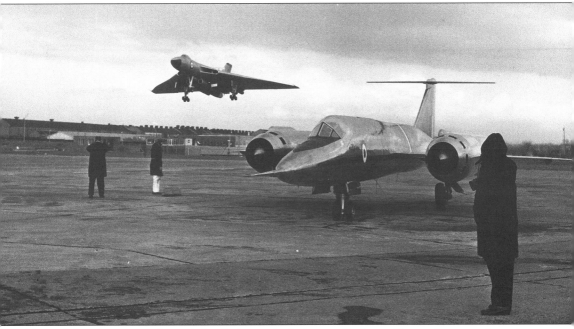

Two of the three aircraft used for flight trials during preliminary Concorde research and development testing. In flight: an Avro Vulcan, which was used as a flying test bed for Concorde's Olympus 593 powerplant, approaches to land over the Gloucester Road. On the ground: the supersonic Bristol Type 188, constructed entirely of steel for studying the effects of kinetic heating on aircraft structures at very high speeds.

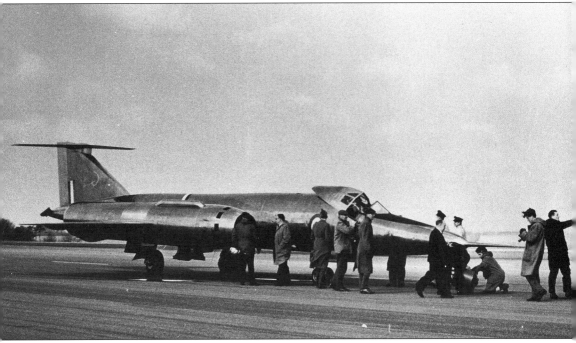

The Type 188 on the runway. Despite the busy activity around the aircraft, its contribution to the Concorde development programme was disappointing, due to its limited performance.

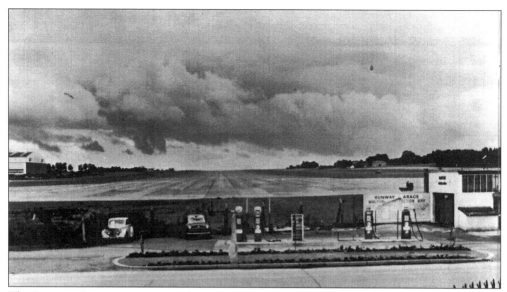

The Runway Garage – appropriately named but unfortunately sited. Its days were brought to a close when it was exposed to the full fury of the jet exhaust from the Vulcan flying test bed. The garage was rebuilt, but the owner wisely decided to reposition it a little further down the road.

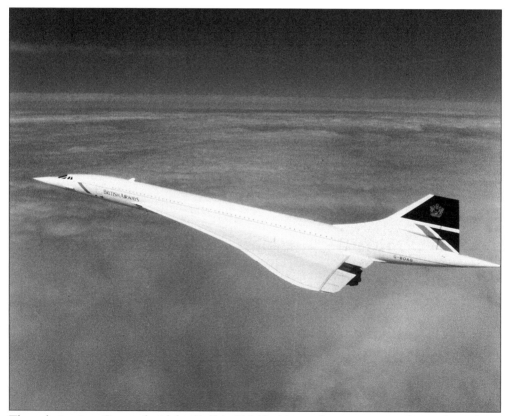

The culmination. Concorde Alpha Golf, in British Airways livery, poses its elegant form above the clouds.

Six

The Royal Air Force in Residence

Although Filton airfield was originally conceived for use by a non-military organisation and is today wholly taken up by civilian aviation, for a great part of its life it has been home to various service flying units.

Once the First World War had started, it was not to be long before the aerodrome at Filton saw its first military aviators. By December 1915, squadrons of the Royal Flying Corps were using it to work up to an operational standard before flying off for active service in France or elsewhere.

Nº 19 Squadron was based there for a time in 1916 and the first two photographs feature some of that squadron's ground crew.

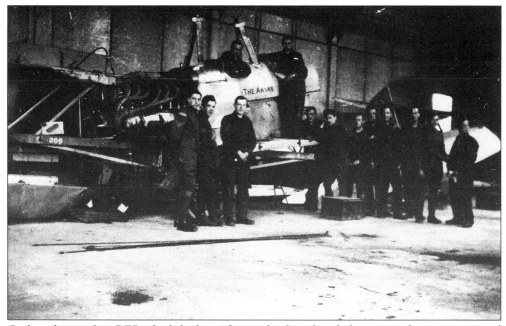

Gathered around an RE7, which looks as if it needs a bit of work done on it if it is ever to stand a chance of taking to the air again...

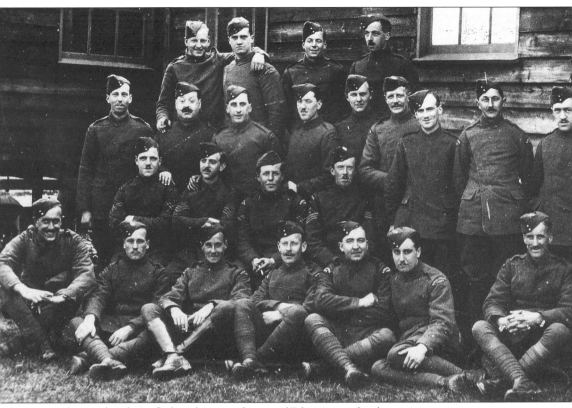

Other ranks of "C" flight relax outside one of Filton's wooden huts.

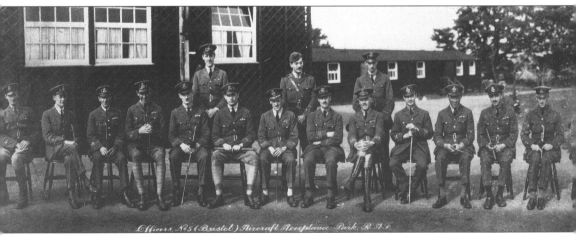

Officers, No5 (Bristol) Aircraft Acceptance Park, R.A.F.

Filton was also the home of No5 aircraft acceptance park. This unit received aircraft from the manufacturers and flight-tested them for acceptance before delivery to the squadrons. This picture, taken in July 1918, is of the officers of that unit, who at about that time included Cyril Uwins amongst their number.

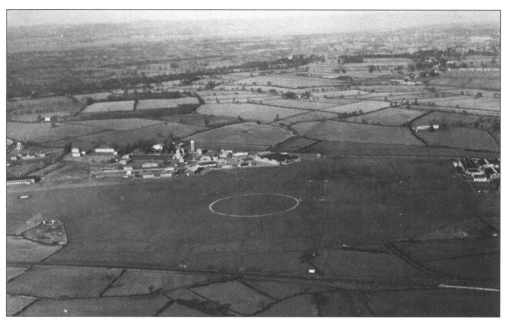

Looking north in 1929. The RAF site is occupying its triangular parcel of land on the southern side of Hayes Lane. The landing circle was often to be seen marked out on the all-grass airfields of those days. After the war, from 1923 onwards, the airfield housed one of the RAF's initial flying training units, variously designated Nº 2 Reserve Flying Training School, Nº 2 Elementary Flying Training School and Nº 12 Reserve Flying School (post-1945). It was in 1929, however, in the halcyon days of flying, that Filton received its very own permanent Royal Air Force squadron, with the formation of 501 (City of Bristol) Special Reserve Squadron, whose personnel consisted largely of reservists who lived and worked in the local area (the "weekend fliers"). It was formed as a bomber unit, initially equipped with 1914-18 de Havilland 9As, but these were soon replaced by the more up-to-date Westland Wapiti Mk II.

The Officers' Mess at RAF Filton (still standing, although now deserted and not easily accessible). Behind are the Station Commander's married quarters.

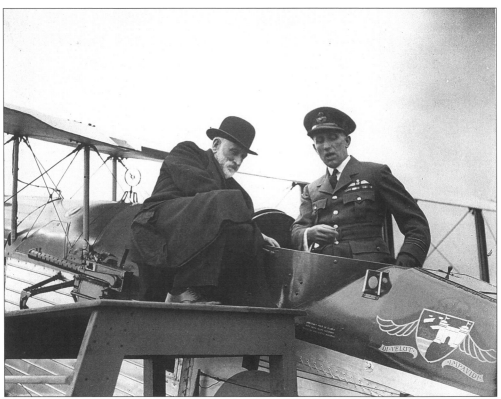

Alderman Clothier, Lord Mayor of Bristol, being shown over a Wapiti by Sqn. Ldr. Sugden, during a visit to 501 Squadron. On the side of the fuselage are displayed the arms of the City of Bristol.

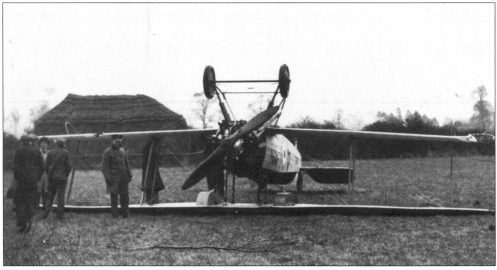

Matters do not always run smoothly, even in the best-regulated units: an Avro 504N belonging to the Squadron which ended upside down in Farmer King's field on Gipsy Patch Lane, in 1932.

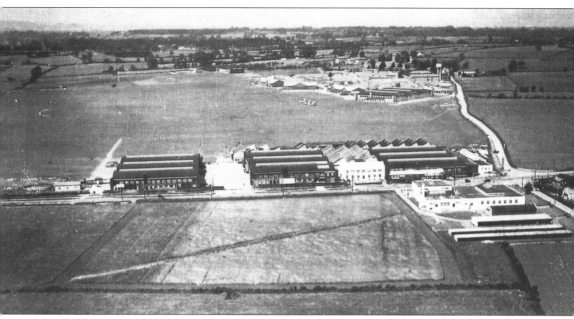

The airfield in 1930, looking towards the west. During the First World War, the hangars in the foreground originally housed No. 5 aircraft acceptance park, before later being taken over by Bristols for their first aero engine factory. The RAF camp buildings lie beyond them on the other side of the landing ground. By the look of it, three of 501's Wapitis are parked on the grass. To the right of the RAF site, Hayes Lane still wends its way from the Gloucester Road towards Charlton.

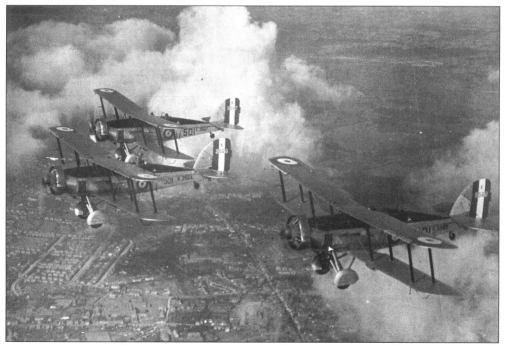

In March 1933, the Wapitis were replaced by the Westland Wallace. These three Squadron Wallaces were photographed in formation over Staple Hill on 19th September 1933.

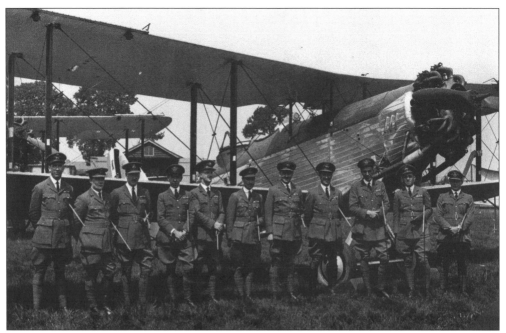

The officers of 501 Squadron lined up in front of a Wallace in 1934. The CO was Sqn. Ldr. Elliot, later Air Marshal Sir Walter Elliot.

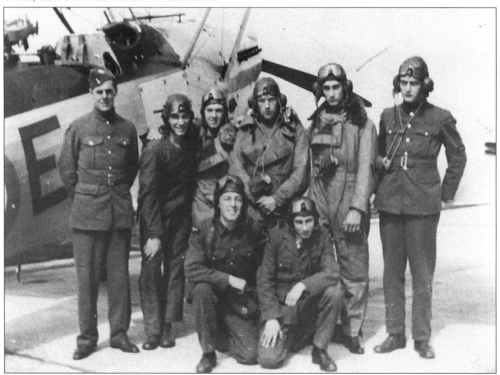

In 1936, the squadron was re-equipped once more – with the Hawker Hart day bomber, shown here. Like the Wapiti and the Wallace, it was a two-seater, and here a group of the Squadron air gunners stand, ready for instant action, complete with helmet, goggles and Gosport tubes.

In March 1939, the unit was re-designated 501 County of Gloucester (Fighter) Squadron (motto: *Nil Time* – Fear Nothing) of the Auxiliary Air Force, and re-equipped once more, this time with Hawker Hurricanes. Less than six months later, as peace was about to give way to war, the squadron's personnel found brief but uncompromising invitations like this one arriving on their doormats. They were "in" for the duration and 501 had become a full-time operational part of the country's war machine.

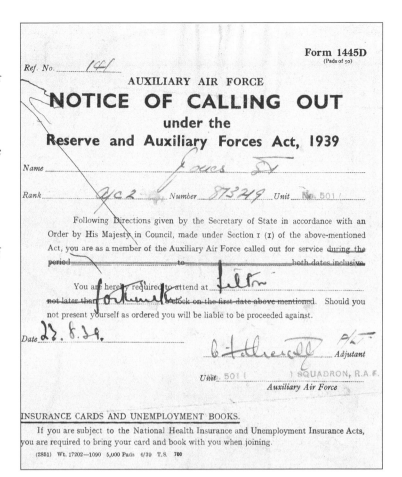

Form 1445D
(Pads of 50)

Ref. No. _141_

AUXILIARY AIR FORCE

NOTICE OF CALLING OUT
under the
Reserve and Auxiliary Forces Act, 1939

Name _Jones J._

Rank _A/C 2_ Number _873749_ Unit _No. 501_

Following Directions given by the Secretary of State in accordance with an Order by His Majesty in Council, made under Section 1 (1) of the above-mentioned Act, you are as a member of the Auxiliary Air Force called out for service during the period _____ to _____ both dates inclusive.

You are hereby required to attend at _Filton_ not later than _forthwith_ o'clock on the first date above mentioned. Should you not present yourself as ordered you will be liable to be proceeded against.

Date _23.8.39._

[signature] Adjutant

Unit _501_ SQUADRON, R.A.F.
Auxiliary Air Force

INSURANCE CARDS AND UNEMPLOYMENT BOOKS.

If you are subject to the National Health Insurance and Unemployment Insurance Acts, you are required to bring your card and book with you when joining.

(2851) Wt. 17202—1090 5,000 Pads 6/39 T.S. **700**

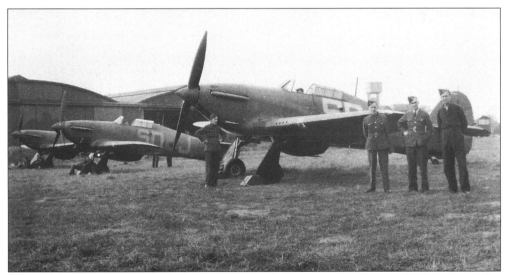

Some of the Squadron's ground crew at Filton, with Hurricanes, in August 1939. Left to right: Ted Coglan, Ted Cann, Mike Hunt and Doug Poole.

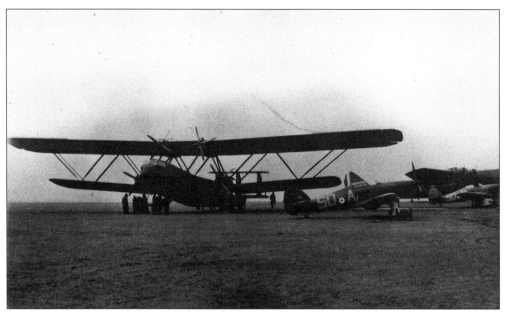

In November, 501 flew off to war, going first to Tangmere, on the south coast. Here, the squadron commander's Hurricane is parked between a Hannibal and an Ensign, both former airliners pressed into service as troop carriers. The date was February 1940, and the "phoney war" had three more months to run. When the balloon did go up, the squadron found itself in France and in the thick of the fighting, as the allied armies crumbled before the German Blitzkrieg.

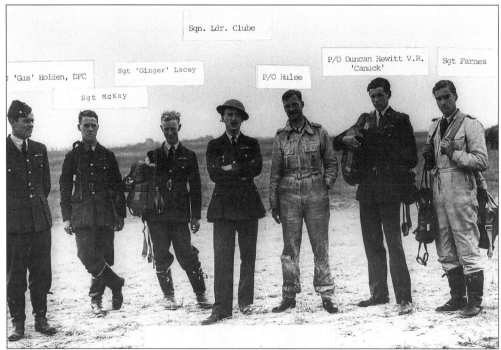

Some of the 501 pilots, on an unknown French airfield. The Squadron was extricated from France, just in time, as chaos descended and organised resistance collapsed.

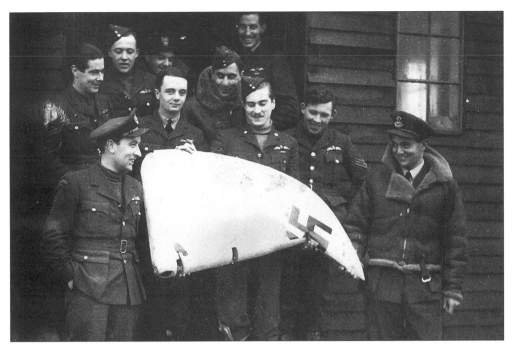

The Battle of France was soon replaced by the Battle of Britain, in which 501 was fully engaged. It returned to Filton only briefly, in December 1940, when this group of pilots was photographed outside a Filton hut, displaying a squadron trophy (a rudder from a shot-down Messerschmitt, now on display in the RAF Museum, Hendon).

Filton offered time for some relaxation after the rigours of battle. Left to right: Ginger Lacey, Kenneth Mackenzie, Tony Whitehouse, Lofty Dafforn and Vic Ekins. Soon, though, the squadron was off again, and although in the next five years it saw plenty of action, collecting one DSO, thirteen DFCs and five DFMs in the process, Filton saw them no more and they ceased to be part of this book's story for the remainder of the war.

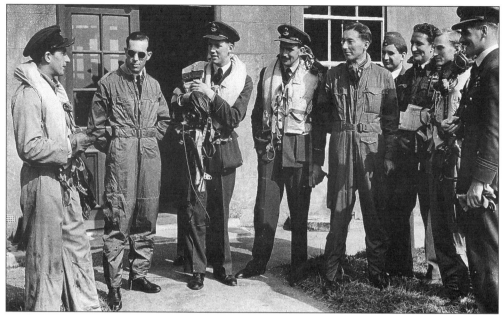

With the ending of hostilities, the squadron was disbanded for the first time, but soon reformed, in 1946, equipped with Spitfires and once more in residence on the RAF site at Filton. Here it resumed its peacetime role, based on weekend activities and a fortnight's annual intensive flying at Summer Camp. The photograph shows pilots gathered outside the crewroom at Filton before departure for Summer Camp at RAF St. Eval, Cornwall, in 1947. Left to right: Sqn. Ldr. James, Flt. Lt. Henderson, Plt. Off. Goodchap, Fg. Off. Rogers, Flt. Lt. Swaby (CFI), Flt. Lt. Sullivan (Eng. Off.), P2 Butch Owens, Flt. Lt. Cleaver (Adj.), Wg. Cdr. Maxwell (Stn. Cdr.).

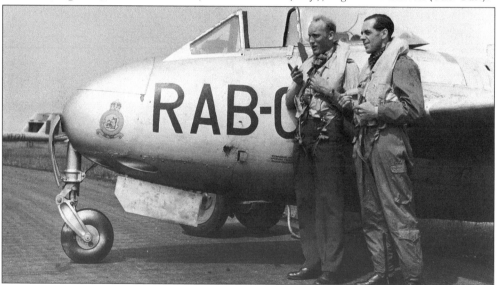

In 1948, 501 converted to jets, with the de Havilland Vampire, and remained equipped with this fighter until, in company with all other RAuxAF squadrons, it was finally disbanded in 1957. Flt. Lt. Steele (left), the squadron adjutant, and the CO, Sqn. Ldr. Henderson, discuss a fine point. The squadron crest, with its boar's head, is painted on the Vampire's nose with the Squadron's identification letters, "RAB" beneath the cockpit.

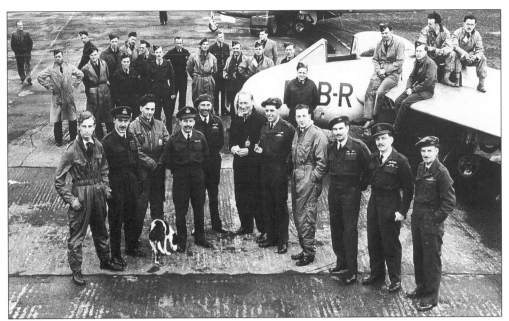

Squadron aircraft and personnel (not forgetting the dog) gathered on the tarmac at Filton. Included in the group are Fg. Off. Collings, Fg. Off. Skuse, Flt. Lt. Steele, Sqn. Ldr. Henderson, and "Turbo", the squadron hound.

The Old Firm: Bert Crooks, George Coward, Nobby Clarke and Ron Regan, standing in front of the squadron's Harvard at Filton in 1949.

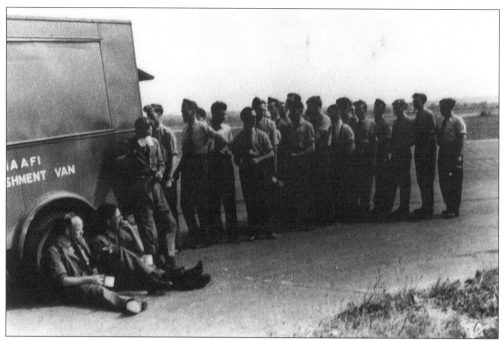

The NAAFI wagon was an essential part of any RAF station's equipment. Here, some of 501's airmen are queueing for "char and wads" during Exercise "Foil" at RAF Odiham, in 1949.

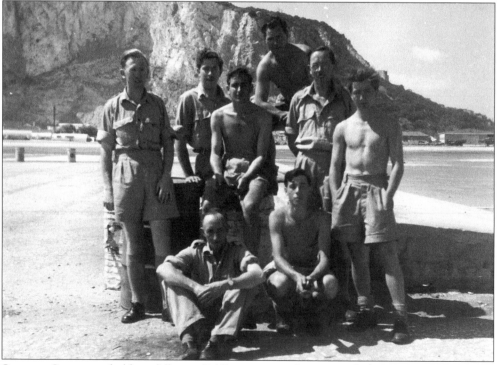

Summer Camp was held at different RAF stations each year, including Manston, St. Eval, Malta and Bruggen. In 1954, they were in Gibraltar. Some of the Squadron ground crew soak up the sun during some off-duty moments.

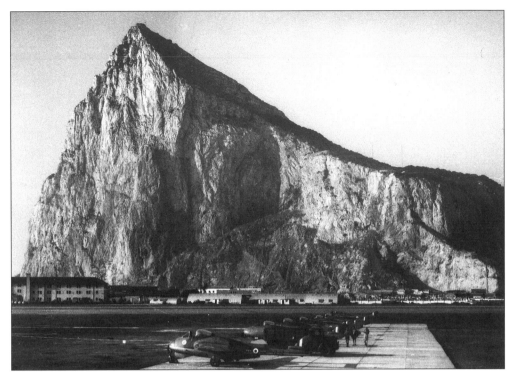

501 Squadron Vampire FB.5s lined up on the Rock.

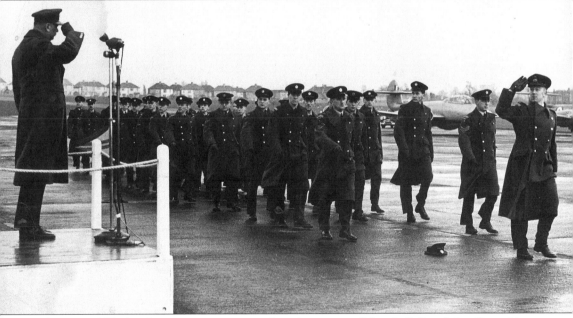

In January 1957, the Government announced its decision to disband all Royal Auxiliary Air Force squadrons, and on 3rd February, 501, together with its RAF Regiment cousin, Nº 2501 Light AA Squadron, held its final, disbandment parade, under appropriately leaden skies. The salute was taken by HRH the late Duke of Gloucester. Led by Flt. Lt. John Matthews, Nº 2501 Light AA Squadron march past the saluting base.

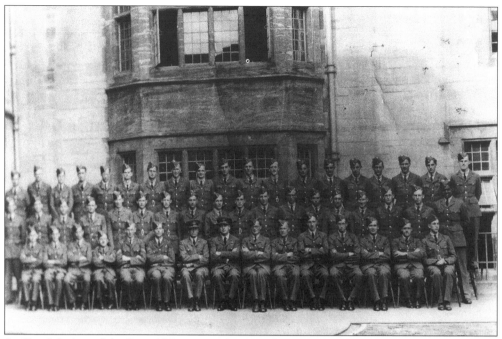

Staff and Cadets of the Bristol University Air Squadron in 1941. The Squadron was formed on 25th February in that year.

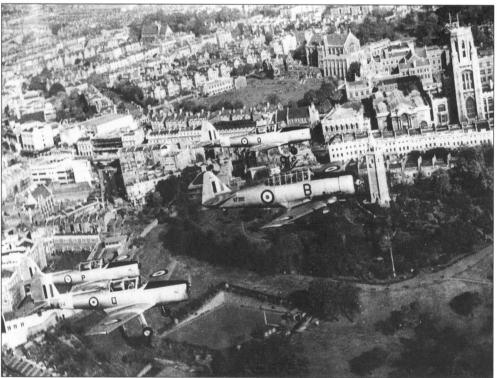

Three of the Squadron's Chipmunks, led by the Squadron's Harvard, fly past the unit's Alma Mater.

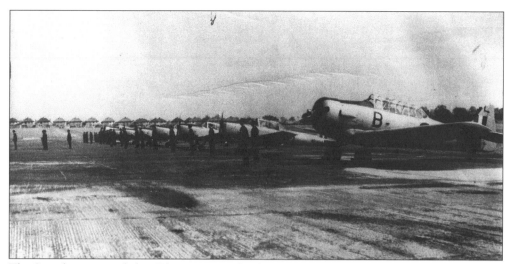

The Squadron is paraded at Filton in 1955, for the annual AOC's inspection.

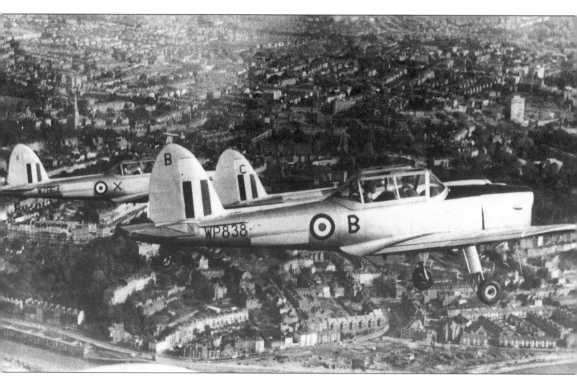

Three squadron Chipmunks over Bristol, on 13th October 1963.

For over thirty years after 501's disbandment, the Royal Air Force presence at Filton was perpetuated by the University Air Squadron and N⁰ 3 Air Experience Flight. Nowadays, however, these two units operate from RAF Colerne, leaving Filton, for the first time in over sixty years, without any service unit at all. Above is the former Guard Room, as it was in February 1989.

N⁰ 1 barrack block, its door half off its hinges. Today, the former RAF site, which once bordered the now-defunct Hayes Lane, has lost touch with the outside world. The stern wire mesh fence which completely encloses the airfield is placed some way to the north of the site, along the edge of Highwood Road. The buildings, through which have passed decades of RAF men, from erks to Air Marshals, now stand empty in their leafy precinct, inhabited only by ghosts. The camp roadways, once traversed by all kinds of vehicles, from one-tonners to fire tenders, lie deserted.

Seven

Charlton

On 9th April 1969, with the throttles fully open and reheat ignited, the four Olympus engines ejected a crescendo of noise and the first British-assembled Concorde began to roll forward at the start of its maiden flight. Directly beneath its wheels, buried under the concrete runway, lay the remains of an English village.

Twenty years earlier, the maiden flight of another, less-successful but, in its way, equally innovative airliner project – the Brabazon – took place from the same runway.

Some time before, the Brabazon contract having been awarded to Bristols, it had been realised that Filton's runway would not be long enough for the new giant being planned. During the war, 2,000-yard runways had been the norm; Filton's 1,500 yards was certainly too short. The only solution seemed to be extension of the runway to the westward.

Down the years, the people of Charlton would have become accustomed to the presence in their skies of the aeroplanes using the neighbouring airfield of Filton. At first, the ploughman behind his team, the landlord of the Carpenters Arms in his doorway, or the housewife hanging out her washing would have been intrigued to see, across the fields, the flimsy Boxkites and other strange shapes detaching themselves from the earth and performing slow and stately circuits around the little airfield beside the road to Gloucester.

As the years went by, ever-faster and more powerful machines were to be seen taking off and climbing noisily over their heads. In 1941, the tarmac runway was laid down. It ended just short of the village, on the other side of the new bypass, but pointed, did the inhabitants but know it, straight at its heart.

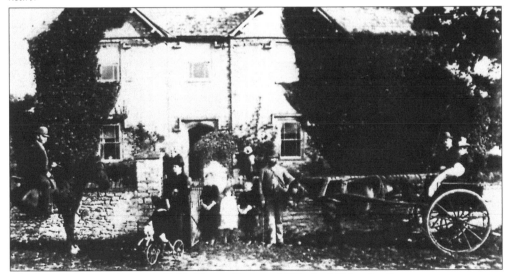

Charlton in Victoria's reign. Gable House Farm in 1888: the Hillier family.

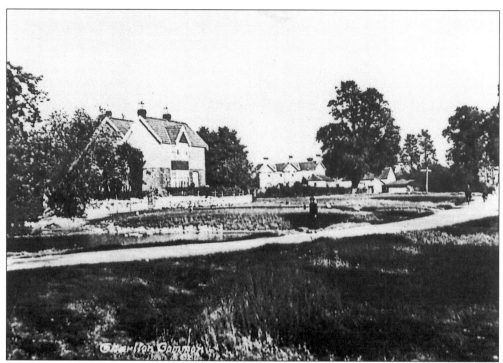

Charlton Common in the 1920s, by the corner of Hayes Lane. Elmhurst is on the left, with Gable House Farm in the distance.

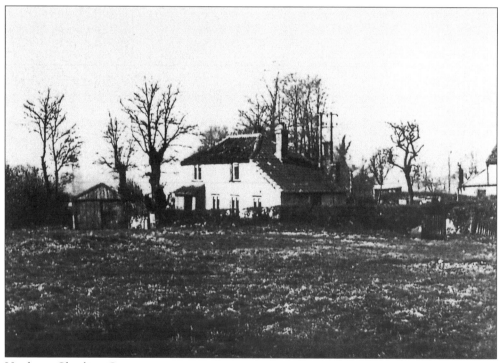

Hook, on Charlton Common.

114

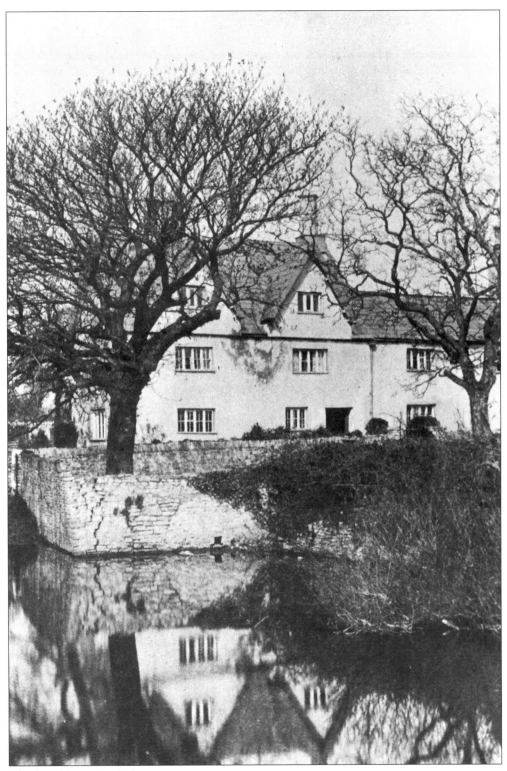

Charlton House in 1918.

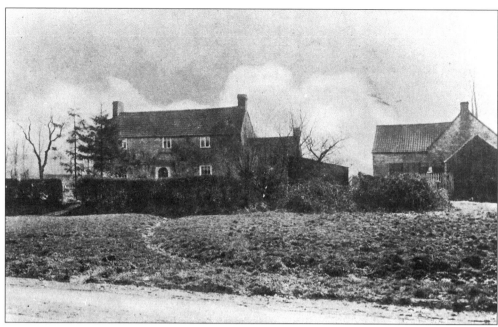

Fir Tree Farm (above) and Dove Farm (below) in 1918. The former, now called Fir Tree Cottage, survives today.

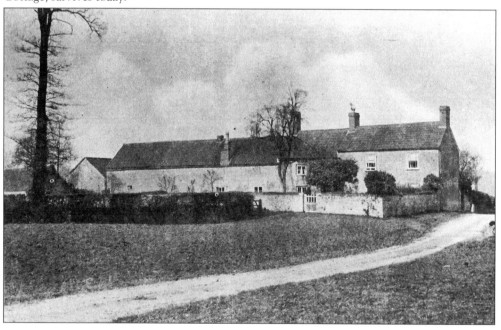

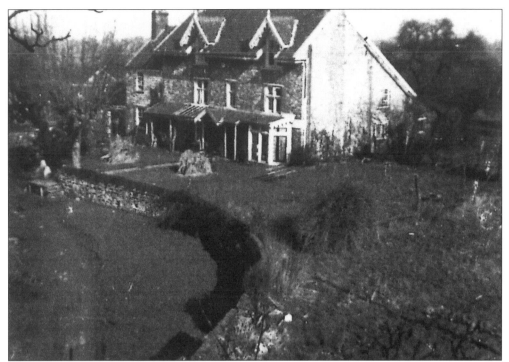

Charlton Farm, occupied by the Pearce family. Lighting was by acetylene gas.

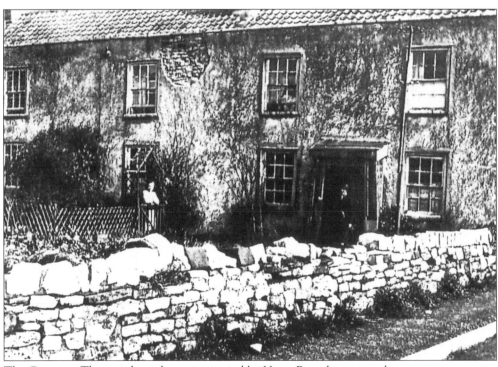

The Cottages. That on the right was occupied by Harry Bees, harness maker.

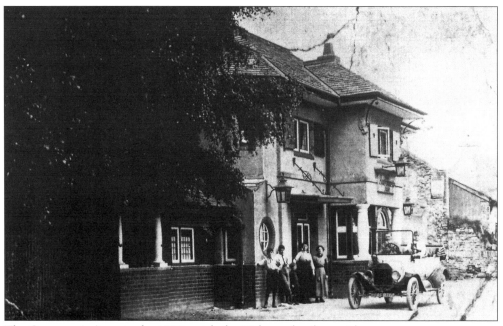

The Carpenter's Arms in the 1920s, with the Wilmott family outside.

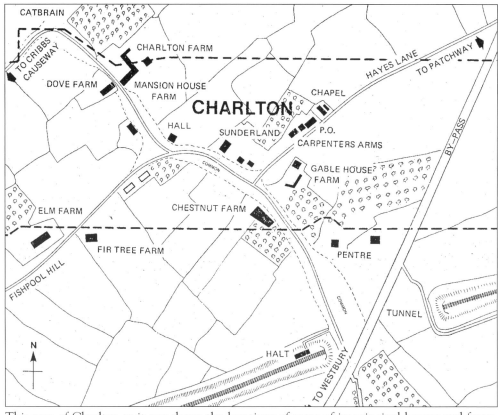

This map of Charlton as it was shows the locations of some of its principal houses and farms. The dotted line marks the land swallowed up by the airfield.

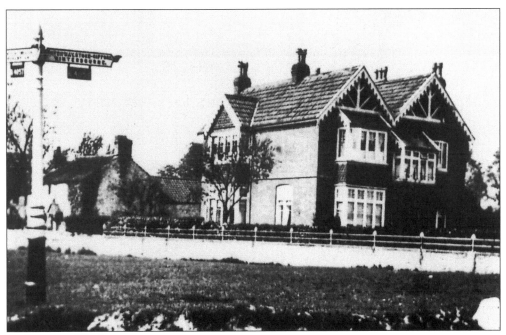

A close-up of Elmhurst.

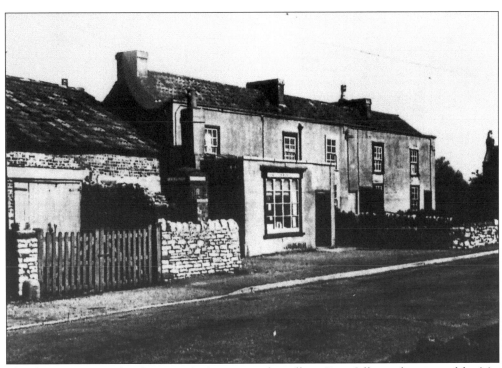

This house, next to the Carpenter's Arms, was the village Post Office, administered by Mrs Goodfield.

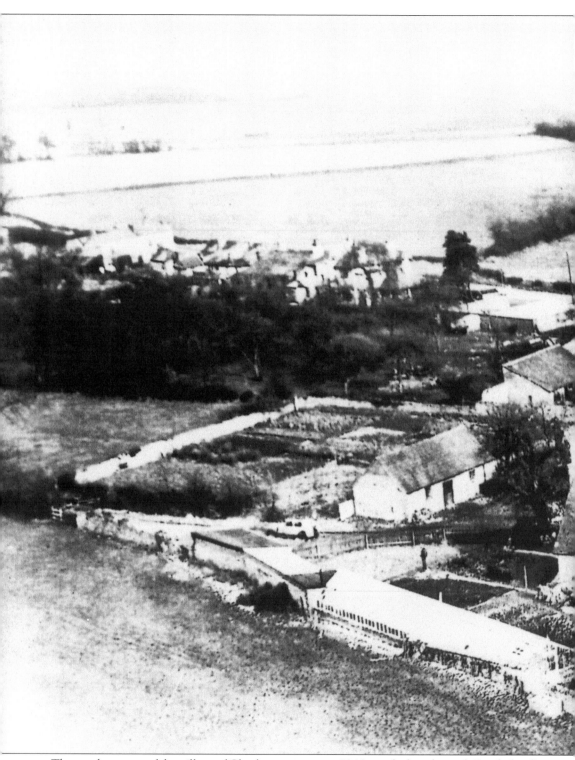

The northern part of the village of Charlton as it was in 1946, just before the end. Sunderland's, or Charlton House, is in the foreground, Elmhurst is just beyond it, and the Carpenter's Arms

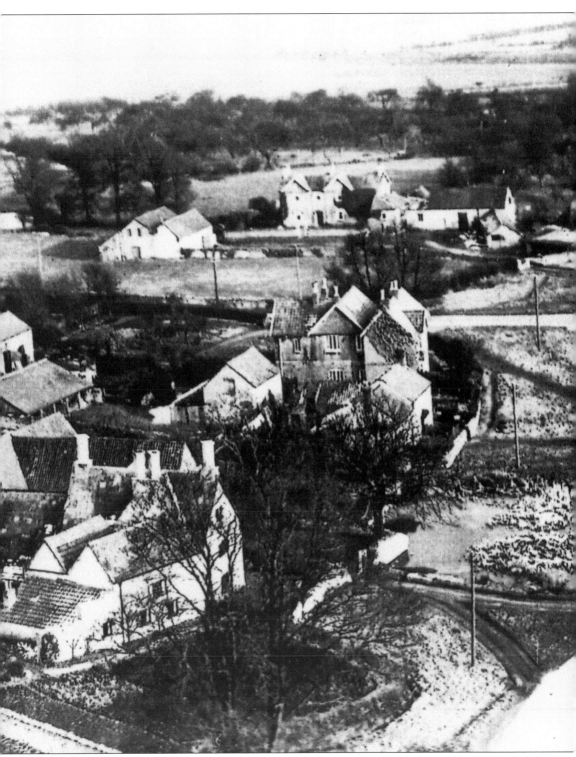

and the Post Office lie on Hayes Lane, beyond the orchard, while Gable House Farm is in the distance on the right. The airfield boundary is marked by the far edge of the trees.

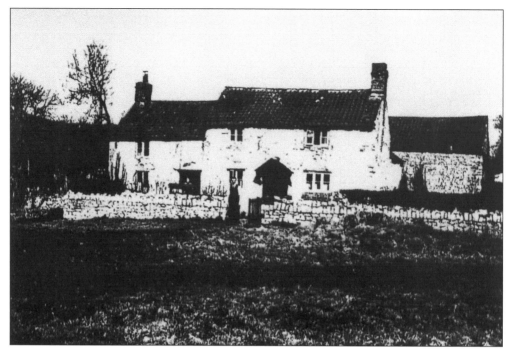

Rose Cottage in 1946.

Another view of Charlton Common, taken in 1946.

Gable House Farm in 1946.

Gable House Farm in 1946 also. Dewsbury Hillier is standing outside his front door.

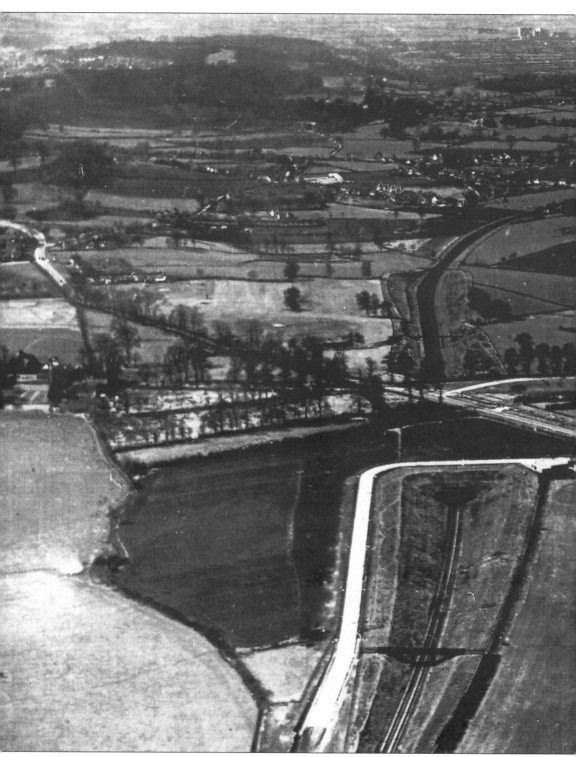

That same year the axe fell. The decision was taken to extend the runway by a further 1,200 yards. Charlton was in the way. This photograph faces west, with the smoke of Avonmouth in

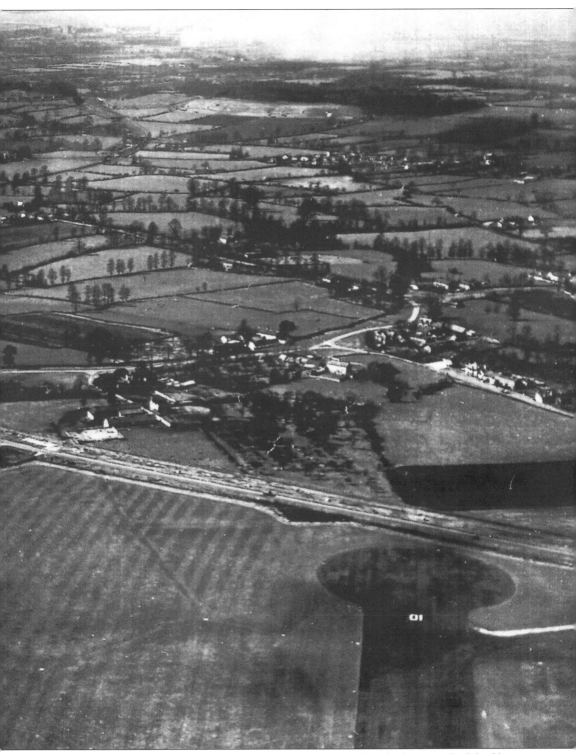

the distance. The old, shorter runway can be seen ending just before the bypass, which had been
built a little while before the war. The hapless village lies beyond, intact but vulnerable.

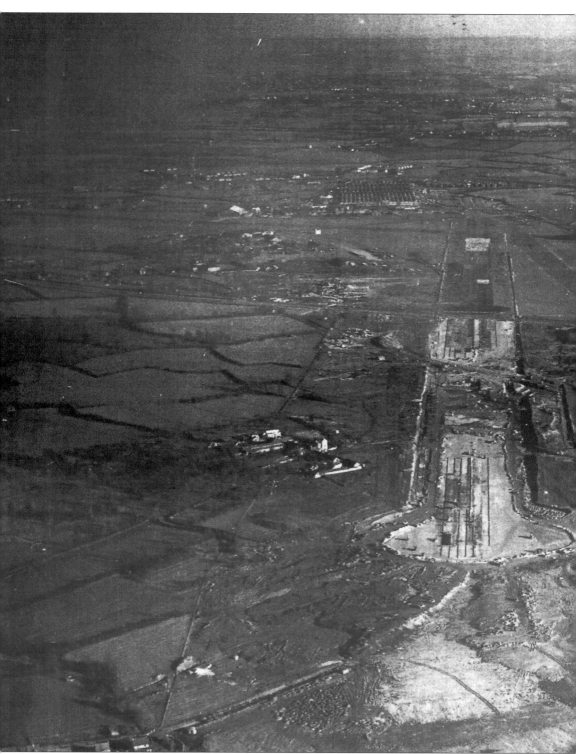

After, looking east. Elm Farm and Fir Tree Farm survive to the south, as do the farm buildings to the north. Nearer Filton, the white walls of Cedar Lodge (previously Pentre) can be seen,

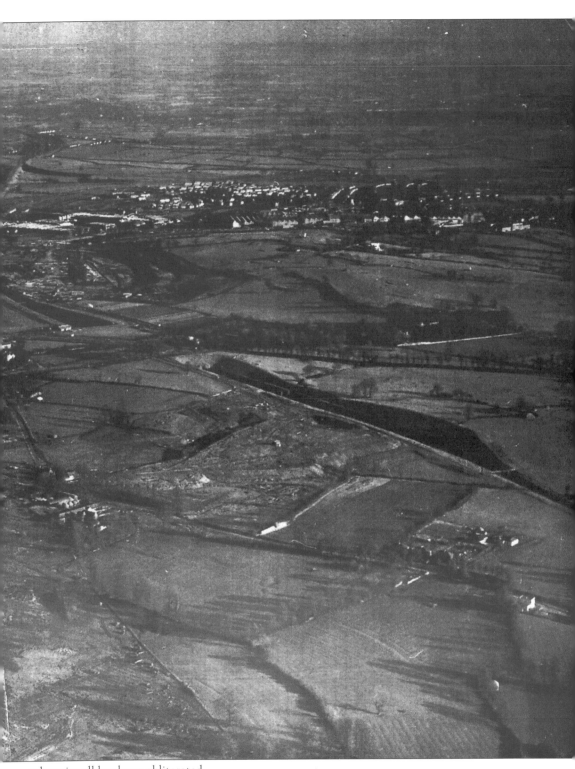

otherwise all has been obliterated.

Bibliography

ASHWORTH, Chris: *Action Stations: 5. Military airfields of the South-West.* (Patrick Stephens)

BARNES, C.H.: *Bristol Aircraft since 1910.* (Putnam)

HARRIS, W.L.: *Filton, Gloucestershire: Some account of the village and parish.* (W.L. and L.N. Harris)

POWNEY, C: *The Village that Died* (Bristol Dynamic News, Vol.3 Iss.2, Feb 1981)

WAKEFIELD, Kenneth: *Target Filton.* (Redcliffe)

WATKINS, David: *Fear Nothing: The History of 501 Squadron R.Aux.A.F.* (Newton)

Acknowledgements

First and foremost, I should like to express my gratitude to Noel and Leslie Harris, who initially pointed my feet in the right direction.

The photographs have come from many sources, but for nearly half of them I am indebted to Colin Powney, for allowing me to use so many from his extensive collection. My thanks are also extended to Derek James, for many of the aircraft photos, as well as his freely-given help and advice.

Other photographs were obtained from the Bristol Record Office, Gloucester Record Office, British Aerospace, Rolls-Royce, the Patchway History Group, the Royal Aeronautical Society, the Royal Air Force Museum, Bristol University Air Squadron, Bruce Robertson, Cliff Wall, Adrian Jones of the Horseshoe Inn and, last but far from least, 501 Squadron Association.

My thanks for their help also go to John Williams and his staff of the Bristol Record Office, Doug Dyson of the Rolls-Royce Heritage Museum at Patchway, Keith Selway and Steve Hicks of the Patchway History Group, Mike Goodchap and Bill Hickman of 501 Squadron Association and Flt. Lt. Barry Leech RAF (Retd), Adjutant of Bristol University Air Squadron.